MOTHER OF GOD SIMILAR TO FIRE

Icons by
William Hart McNichols
with Reflections by
Mirabai Starr

ORBIS BOOKS
Maryknoll, New York 10545

Founded in 1970, Orbis Books endeavors to publish works that enlighten the mind, nourish the spirit, and challenge the conscience. The publishing arm of the Maryknoll Fathers and Brothers, Orbis seeks to explore the global dimensions of the Christian faith and mission, to invite dialogue with diverse cultures and religious traditions, and to serve the cause of reconciliation and peace. The books published reflect the views of their authors and do not represent the official position of the Maryknoll Society. To learn more about Maryknoll and Orbis Books, please visit our website at www.maryknollsociety.org.

Manufactured in Italy

Library of Congress Cataloging-in-Publication Data

McNichols, William Hart.
 Mother of God similar to fire / icons by William Hart McNichols ; with reflections by Mirabai Starr.
 p. cm.
 ISBN 978-1-57075-894-2 (cloth)
 1. Mary, Blessed Virgin, Saint—Meditations. 2. Mary, Blessed Virgin, Saint—Art. 3. Icons. I. Starr, Mirabai. II. Title.
 BT608.5.M39 2010
 246'.53—dc22
 2010006026

We would both like to dedicate this book, first of all, to the people of Taos, New Mexico, our "beloved community."

—WILLIAM HART McNICHOLS AND MIRABAI STARR

For the great authors who have honored me by writing so powerfully and beautifully on the Icons:
Daniel Berrigan, SJ: *The Bride, Images of the Church;*
Megan McKenna: *Mary Mother of All Nations and Christ All-Merciful;*
John Dear, SJ: *"You Will Be My Witnesses";*
Mirabai Starr, for this book;
Jim Martin, SJ, for a forthcoming Icon book on the Jesuit saints.

And a special thank you to my representative Pamela Scalora of St. Andrei Rublev Icons.

—WILLIAM HART McNICHOLS

To Fr. Bill McNichols, who builds bridges from love to love.
And to Jenny Bird, who turns it all into song.

—MIRABAI STARR

Litany to the Blessed Mother

by Holy New Martyr Fr. Jerzy Popieluszko of Warsaw (1947-1984)

(Fr. Popieluszko, chaplain to the Solidarity movement in Poland, was murdered by security police on October 19, 1984.)

Mother of those who are deceived,

Mother of those who are betrayed,

Mother of those who are arrested in the night,

Mother of those who are imprisoned,

Mother of those who suffer from the cold,

Mother of those who have been frightened,

Mother of those who were subjected to interrogations,

Mother of those innocents who have been condemned,

Mother of those who speak the truth,

Mother of those who cannot be corrupted,

Mother of those who resist,

Mother of orphans,

Mother of those who were beaten on the day of your feast,

Mother of those who have been molested because they wore your image,

Mother of those who are forced to sign declarations contrary
to their consciences,

Mother of mothers who weep,

Mother of fathers who have been so deeply saddened . . .

We beg you, O Mother in whom resides the hope of millions of people,

Grant us to live in liberty and in truth, in fidelity to you and to your Son.

Amen

CONTENTS

PREFACE

"There is only Christ: He is everything and He is in every thing."—Col. 3:11

"So much is He, that He is all and in all, so that no one can deny His presence within. He is not 'here, but not there,' does not prefer this place while avoiding that one, does not incline to one and flee another, He is everywhere and in everyone."
—Adrienne von Speyr

From the age of nineteen I was brought into the life of the Spiritual Exercises of St. Ignatius of Loyola, which consists of four weeks of prayer and meditation on the Life of Christ. The retreat culminates with a glorious burst of light, which launches the retreatant into a life of ministry of "finding God in all things." Once these words settle in your heart, they never leave you. They become the way you live in the world with its great variety of people, as well as the Creation, both damaged and abundant.

The great contemporary mystic and medical doctor, Adrienne von Speyr, said, "No one points to God with such shrewd intelligence as St. Ignatius." Anyone who has been formed by Ignatian spirituality will attest to his way of seeing, which becomes a part of you after a period of time.

There is a childlike awe in being called to create along with the Holy Spirit, to continue, as we say in the Fourth Eucharistic prayer, "to complete His work on Earth." Ignatius thoroughly knew the world, but his intimacy with God never allowed him to sink into cynicism, suspicion, or fear of the world and God's people. It is my belief, and the ancient belief of the Eastern Orthodox Churches, that praying with

Icons can renew our intimacy with God and the childlike stance Jesus insists upon in the Gospels.

From 1983 to 1990, I lived a totally life-altering experience working as a friend, minister, and hospice chaplain in and around New York and New Jersey for people with HIV-AIDS. People's suffering from a multitude of related illnesses and complications was almost unspeakable; added to this anguish was wave after wave of vicious prejudice and many forms of abuse. It was a life for all of us in the eye of the storm, and yet a life rich with friendship, love, and the imposed altered state of being, at the beginning of a world pandemic.

I was still in that state when I arrived in Albuquerque in September 1990. I was to become an apprentice to the Russian-American Master, Robert Lentz. Because I had spent so many years with the dying, as a witness or midwife to the Second Birth, my new life of continual communion with the holy souls of those who had died did not feel strange to me. What I had hoped would be a year-long apprenticeship turned into six years as intense and demanding as my life in ministry to people with HIV-AIDS.

From this distance now of twenty years, I can see how gracefully and naturally one life flowed into the other. I experienced my first six years as a student iconographer as a sacred time out of time, and it was a somewhat violent struggle for me to come out of it.

"More honorable than the Cherubim, more glorious beyond
 compare than the Seraphim.
No mind comprehends how to praise thee fittingly."
 —Orthodox Prayer to the Mother of God

During the first seven months of my apprenticeship, before I knew what I was doing, I was commissioned by the Archdiocese of Denver to create an Icon of Our Lady of the New Advent (feast day December

16th). This inspiration of the New Advent had appeared on the first page of Pope John Paul II's first encyclical *Redemptor Hominis*, and was sung like a refrain throughout his papacy. Suffice it to say that after this, I was swiftly and permanently ushered into the time of the New Advent and, in practice, the Mission of the New Evangelization proclaimed by the Holy Father. In my own life, especially in childhood, art was the primary way I was introduced to the two thousand years of Christianity. It took me several years and an actual meeting with the Holy Father where I stepped into the transforming sphere of his holiness before I knew what hit me or how this experience would change my life forever.

I have no intention of presenting myself as Orthodox, yet over the years I have felt a growing love for the ancient Orthodox Church's theology, spirituality, history, and of course her magnificent Icons. The purpose of this book is to present fifty of the sixty-seven Icons and images I have been given of the Mother of God. I hope that you too will experience some of the enigmatic mystery, love, and adoration I have found during the hours of creation.

I invited my dear friend Mirabai Starr to come to these images and Icons as a person without familiarity, as a kind of "every woman" meeting them for the first time. She is a bright and highly respected author and translator and is gifted above all with a genuine poet-touched soul. Having lost a child, she has dedicated herself to a ministry of sitting with the bereaved.

Mirabai and I agree that these meditative prayers are just an opening, so they are kept brief, with my own minimal comments at the back of the book. We offer a contemplative space for you to enter and find your own relationship with the images and words. It is our fond hope that these Icons and images will inspire you to search the depths of their meanings, whether on the Internet or in such classic works as *The Art of the Icon* by Paul Evdokimov, which is my own personal favorite.

We also hope you will create your own meditations along with prayers as the Icons live with you and you with them. We recommend that you gather with others and read the prayers aloud together as a powerfully transformative spiritual practice.

May God bless your time of gazing, and know that truly, truly you are gazed back upon with a Love that is forever.

Mary is the dawn that precedes and reveals the Sun of Justice…. The difference between the first and the second coming of Jesus will be that the first was secret and hidden, the second will be glorious and dazzling; both will be perfect, because both will come through Mary. This is a great and holy mystery that no one can understand; "let all tongues fall silent." —St. Louis de Montfort

Fr. William Hart Dominic McNichols
Taos, NM
February, 2010

INTRODUCTION

My soul magnifies the Lord, and my spirit rejoices in God my Savior, for he has looked with favor on the lowliness of his servant. Surely from now on all generations will call me blessed.　　　　　　　　　　—The Magnificat: Luke 1:46-49

During these times of mingled hope and despair, we urgently need Mary's radical message: *you are unconditionally loved.* Many of us are grappling with paradoxical impulses: we long for the sacred yet are disillusioned with the limitations of formal religious traditions; we are outraged by senseless global wars yet refuse to be angry activists. The love that Mary offers neutralizes politics and transcends dogma. It does not matter what faith, if any, you subscribe to. What matters is that you simply let yourself be loved.

Mary is the quintessential Mother, the feminine face of the Holy One, fierce protector and gentle consoler. She is inspiration, wisdom, vital essence of compassion and forgiveness. She reaches into the heart of the wounded world with tangible healing. She is Mother of the Divine, and Mother of us all.

There is good reason that depictions of Mary abound across the planet and through the centuries. She is carved in stone and cast in plaster, painted on the canvases of the masters and splashed in murals on city walls, embossed in metal, woven into tapestries, silk-screened on t-shirts. No other image in western art has expressed more tenderness, compassion, warmth, and acceptance. Mary is forever seen embracing, sheltering, kissing, lifting, reaching, praying for all beings.

As the embodiment of the eternal Mother, Mary melts the boundaries of religion and manifests in a thousand forms. At times she exudes the delicate tenderness of mercy and compassion; and at other times she burns with the ferocity of protection and transformation. She is the soft brush of lips on a fevered brow, and a gushing fountain of loving strength.

In biblical scripture and in legend, Mary variously appears as the wide-eyed girl, spellbound by the apparition of an angel, and the child-bride with a baby almost too big for her arms. She is the fearless woman directly facing the ultimate ripening of pain for herself and her offspring. She is the frantic parent of a lost boy, and the perceptive woman at a wedding who quietly nudges her son out of the nest and into his destiny of signs and wonders. And she is the *Mater Dolorosa* whose prophesied sorrow has reached its zenith as she watches her son's murder, witnesses the Light fade from the world, and then cradles, once again, her naked child in poverty, in humility, and a faith beyond words.

The Immaculate Conception refers not to the virgin birth of the baby Jesus, but to Mary's own birth: she was conceived and born without stain. Mary was utterly pure throughout her life, the perfect receptacle for the Word of God to take flesh. Patriarchal culture has tried to reduce this purity to a vapid timidity, but nothing could be further from reality. Mary, meek and mild! Who but the most courageous of human beings could possibly agree to take on the task that mighty Mary accepted?

Picture this: it is late at night in the heart of the Holy Land. A young Jewish girl, resigned to her impending arranged marriage to a carpenter, hears a soft rustling and awakes. But instead of the owl she expects to discover at her window, she sees a towering winged man standing at the foot of her bed.

"Rejoice, beloved one!" he pronounces. "The Lord is with you. Blessed are you among women!"

Mary clutches her blanket and presses her spine against the wall, gasping.

"Don't be afraid, Mary," says the archangel Gabriel, "for you have found favor with God. Behold, you will conceive and bring forth a son, and name him Jesus, Light of the World."

The girl protests. "This is impossible! I am a virgin."

"The Holy Spirit will come upon you," Gabriel explains, "and the power of the Most High will overshadow you. The holy one who comes through you will be called the Son of God."

In this moment, Mary knows that this is what she was born for. She takes a

deep breath and sits up straighter in her bed. "Here I am," she says. "Call me the one devoted to the Lord. May it be as you have said. It is done."

The angel's smile illuminates the room, and then he disappears. Mary "keeps these things in her heart," nurturing them in silence.

Early in her miraculous pregnancy, Mary goes to visit her older cousin, Elizabeth, who is incubating a miracle of her own. Long past the age when the childless Elizabeth should have been physically capable of conceiving, she has become pregnant with John the Baptist, who will act as the first witness to the divinity of Jesus.

When Mary enters her cousin's house and calls out her greeting, the baby in Elizabeth's womb leaps for joy. Elizabeth is "filled with the Holy Spirit" and cries, "Blessed are you among women, and blessed is the fruit of your womb!"

Mary responds with a spontaneous canticle in praise of God: "My soul magnifies the Lord . . . for he has looked with favor on the lowliness of his servant." But she does not dwell on her own blessings. Instead, she turns her attention to those who are oppressed. "He has scattered the proud in the thoughts of their hearts," she sings. "He has brought down the powerful from their thrones, and lifted up the lowly. He has filled the hungry with good things, and sent the rich away empty."

Mary thoroughly embodies this identification with the poor and concern for human rights. She gives birth to the Prince of Peace not in the opulence of a palace, but in a manger, in radical humility. The first visitors to the bed of straw where the holy infant lies are not courtiers sent by kings, but simple shepherds, who have been visited by a host of angels and guided by a special star. The shepherds kneel at Mary's feet and share "the good news" the angels had proclaimed: "To you is born on this day . . . a savior."

Mary, a natural contemplative, listens quietly to their account. "She treasures all these words and ponders them in her heart."

When the time comes for the ritual circumcision, Mary and Joseph bring their infant to the Holy Temple in Jerusalem. As they are ascending the steps, an old man approaches them and introduces himself.

"The Holy Spirit told me that I would see the Messiah before I die, and direct-

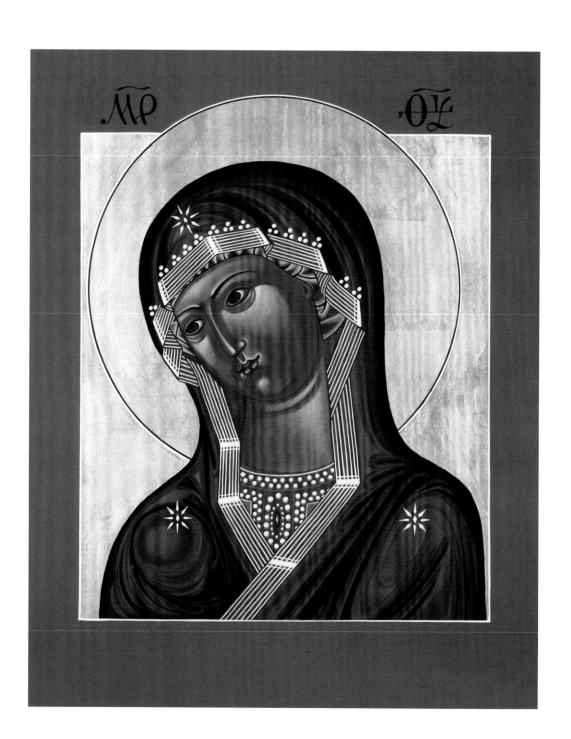

MOTHER OF GOD SIMILAR TO FIRE

Mother of God
similar to fire,
ignite my heart in prayer.
Where once I stood on familiar ground,
selecting my spiritual experiences
like choice morsels from a well-tended larder,
now my garden has gone up in flames
and I thirst only for the Living God.
Let me find him, Mother,
as you do,
deep inside my own ripened being.
Let me swallow the Sacred
and burn with that Presence,
illuminating a way home to the Truth.
Lit from within,
let my blazing heart become a sanctuary
for the weary traveler,
until this long night lifts
and dawn unfolds her new radiance.

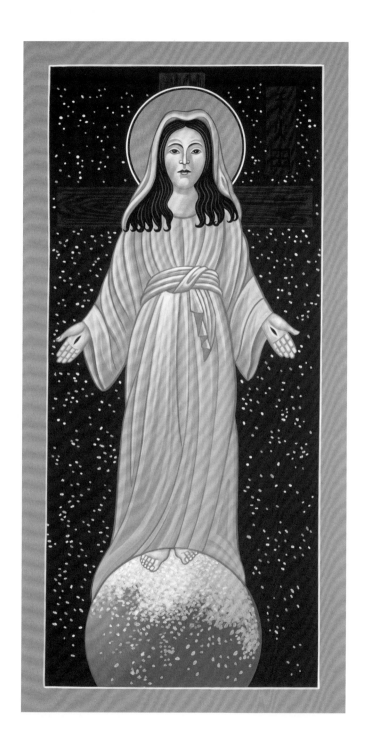

MOTHER OF GOD OF AKITA,
OUR LADY OF THE SNOWS

Universal Mother,
teach me to love the Holy One
as you love the Holy One,
with utter abandon.
Teach me to pray as you pray,
without words or concepts to hinder
my connection with my Beloved.
Teach me to serve the world as you do,
serenely smiling through tears of blood.
Let the peace you proclaim come at last,
blanketing the earth like snow,
permeating the thirsty land
and penetrating the roots of all nations,
so that a new season of goodness
may burst into bloom everywhere.
Everywhere.

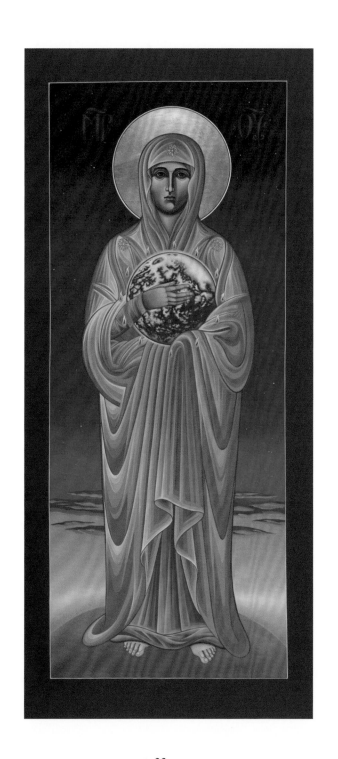

MARY MOST HOLY MOTHER OF ALL NATIONS

Holy Mother of all people,

erase the lines we have drawn to separate us,

nation from nation,

tribe against tribe.

Melt our frozen hearts,

so that we can love again.

Filled with the Holy Spirit

who flows in your wake,

how can we possibly make war

against our brothers and sisters?

Safe in your embrace,

how could we hold onto any concept of "other"?

Blessed One,

we join our voice with yours,

that your message of peace and justice

may penetrate the troubled minds of all leaders:

Let the children of all the countries of the world be one!

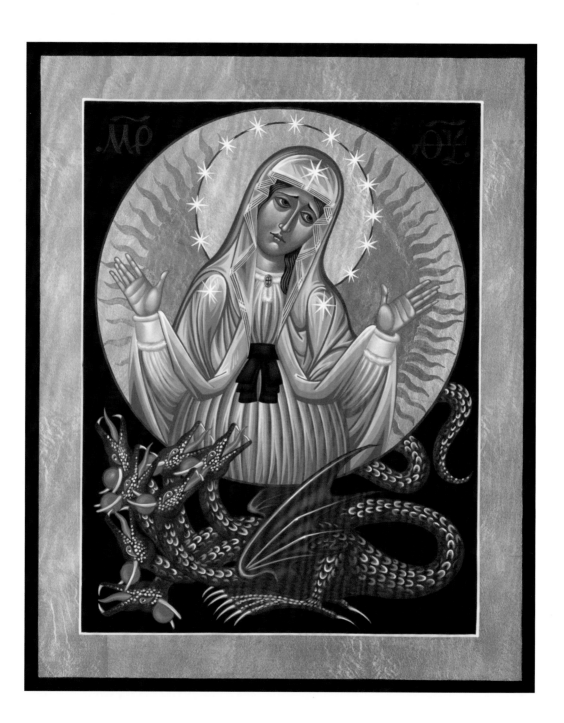

OUR LADY OF THE APOCALYPSE

Queen of the Universe,

in the midst of terrible danger

you labor to give birth to the Prince of Peace.

In the face of violence and warfare

you stand on the moon of mercy.

Plunged into the darkness of greed and corruption

you wrap yourself in a cloak of sunshine.

Surrounded by those who would silence the Word of God

you encircle yourself with a symphony of stars.

Teach me, brave Lady, to be courageous.

Show me the way to stand in the chaos of my agony

and not lose my balance.

Help me to trample the demons of despair that pursue me,

so that I too may be given eagle's wings

and soar to a place of safety

where the Light of the World is born.

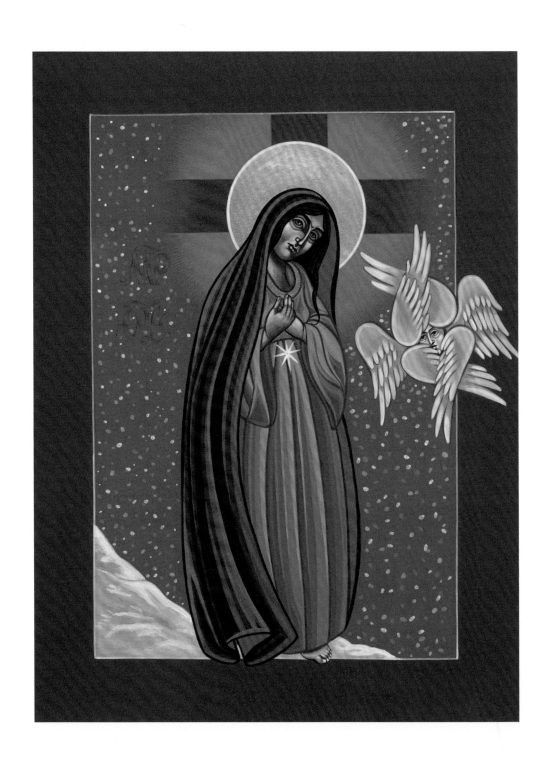

NUESTRA SEÑORA DE LAS NIEVES

Sweet Lady of the Snows,

when we are most convinced

that the light is in danger

of disappearing from this world,

you step through the darkness,

barefoot, enraptured,

and carry the Sun of Justice into our midst.

The highest angelic orders

bear witness to the miracle ripening in your womb.

Within the mysterious heart of deep winter,

the seed of everlasting life is preparing

to break through the frozen mantle

that covers our hearts,

radiating healing and hope

where we had witnessed only desolation.

Holy Mary,

we are ready to be amazed.

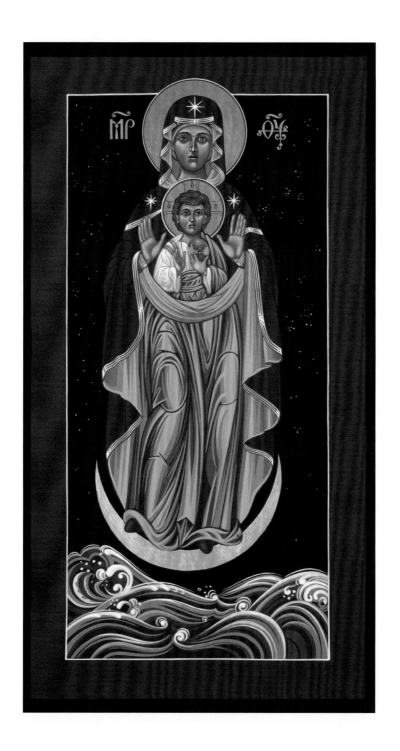

AVE MARIS STELLA (STAR OF THE SEA)

Beloved Mother,

Star of the Sea,

you who carry the one who carries the world,

I need you now.

Rise from the turbulent waters of my life

and show me the way home to my true self.

When the night seems to be closing around me,

threatening to smother me,

all I need to do is remember to call out to you,

and you will breathe new breath into me.

I am exhausted, Mary.

I need you to pull me out of this vortex of worries and regrets,

to navigate this ocean of anxiety and despair.

Extend your loving hand to me now,

and I will summon the strength to reach toward you in return,

and take refuge in the safety of your embrace.

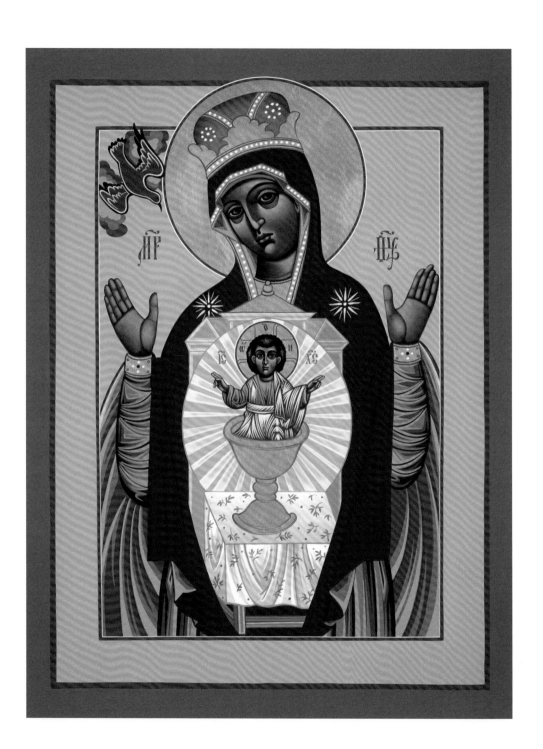

BLACK MADONNA, YOUR LAP HAS BECOME THE HOLY TABLE

Dark Madonna,

Mother of the World,

thank you for making a place for me at the table of the Holy One.

Yours is a feast to which everyone is invited.

In the circle of your generosity, we are safe.

You give me courage to face the darkness and embrace it,

knowing that in the depths of the night,

inside the womb of Spirit,

the light of the world is rising, ready to break through.

Black Virgin,

you have become the tabernacle that cradles the Word of God.

You lift up the Eucharistic chalice in celebration.

You spread your ample lap

and uncover a restorative banquet.

"Come," you say – to me, and to all the world.

Your voice is warm milk, sweetened with wild honey.

"Eat, and be filled."

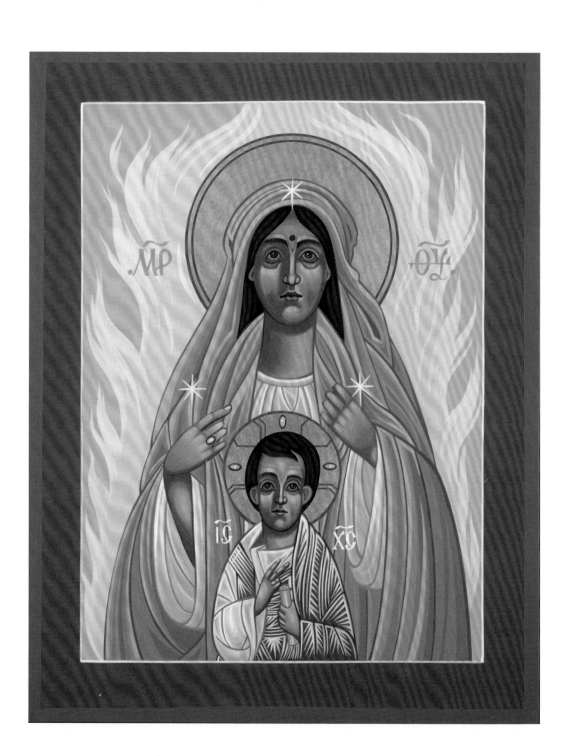

MOTHER OF GOD,
CENACLE OF THE NEW PENTECOST

Mother of God,

you are the safe haven,

the secret room where the lovers of the Divine

gather to remember him,

the oasis where the seekers find each other

in the heart of the desert

and exchange stories of longing and discovery.

The fire of the Holy Spirit

comes pouring into the open chamber of your mother-heart.

In your midst, all are welcome.

Through your voice, everything is understood.

Blessed Mother,

may all faiths find sanctuary in you.

May all paths flow like mountain streams

into the river-valley of your love

and praise the Holy One

with a thousand voices.

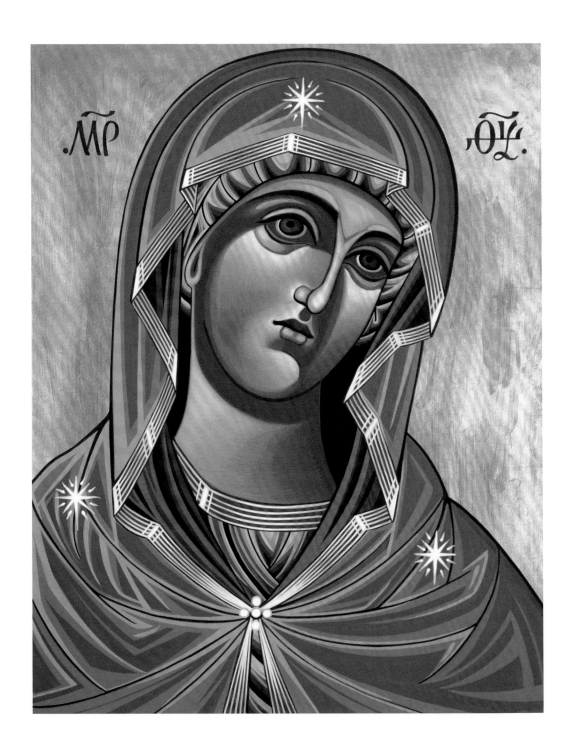

THE ANDRONICUS ICON OF THE
MOTHER OF GOD, CONSOLER OF WOMEN

Mother of mothers who weep,

I come to you on my knees.

The most terrible thing I could imagine has happened:

I have lost my child.

Oh Blessed One,

you know my pain like no other can know it.

You carried the Light of the World in your own body,

and then knelt and swayed as he died,

raged and forgave as he was tortured,

surrendered and were annihilated

as you held his broken body against your breast one last time.

Mother of God,

I have nowhere left to turn.

A tidal wave of grief fills the horizon of my heart.

I do not want to live in a world without my baby in it.

You survived the impossible.

In the wake of your child's death, you were resurrected.

And now your compassion flows over the whole world.

Even in this fire of anguish,

Mother of Mercy,

I have hope of your healing touch.

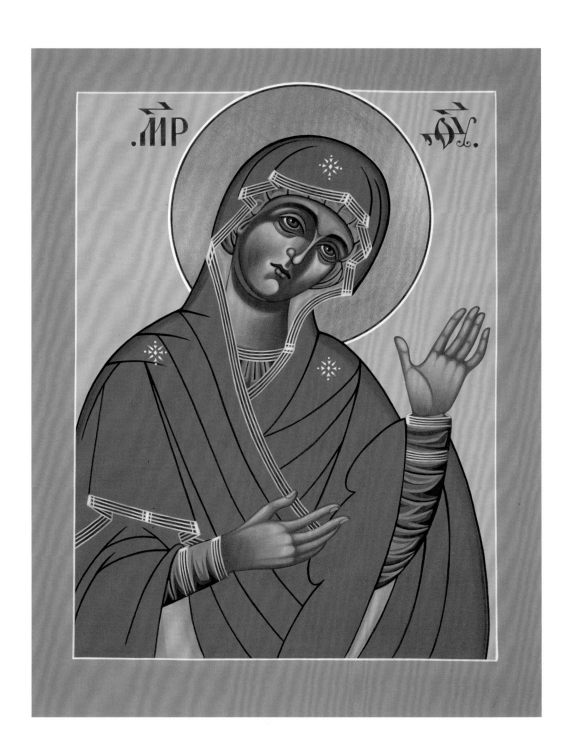

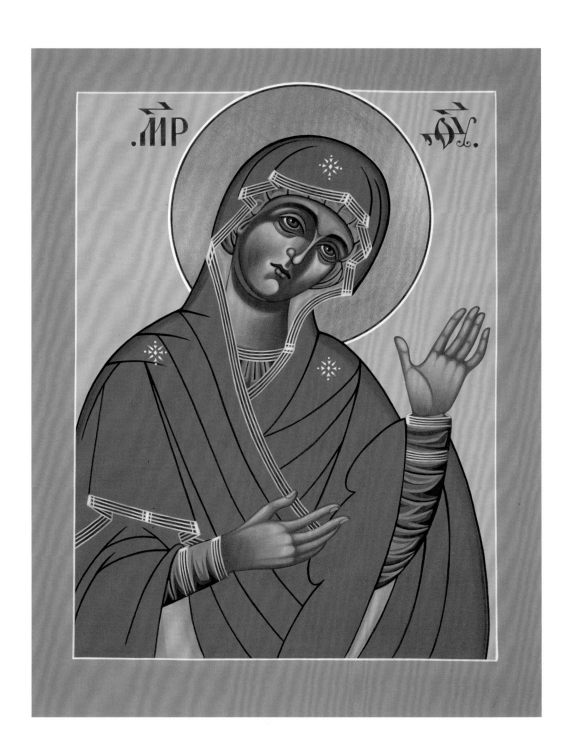

MOTHER OF GOD, SHE WHO HEARS
THE CRIES OF THE WORLD

Mother of Mercy,

the cries of the world keep me awake at night.

I rise from my bed, but I cannot locate the source of the wailing.

It is everywhere, Mother, coming from all directions,

and my heart is shattered by the sheer intensity of suffering.

You of boundless compassion,

expand my heart so that I can contain the pain.

Focus my mind so that I can arrive at viable solutions,

and energize my body so that I can engage in effective action.

Give me the courage to follow the crumbs of heartbreak

all the way home to the place where I can be of real service.

Let me dip my fingers into the dew of your compassion

and scatter it now over the fevered brow of this world.

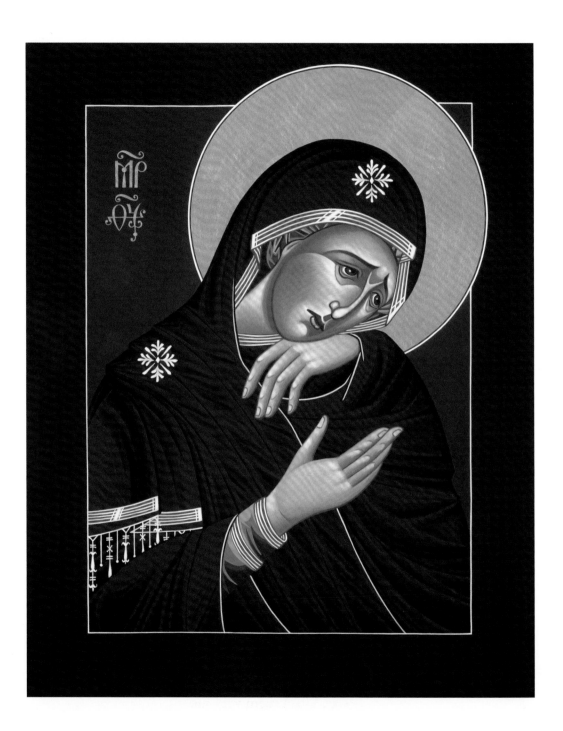

NUESTRA SEÑORA DE LOS DOLORES

Mother of suffering,

you carry the grief of the whole world

in your boundless, shattered heart.

Please, carry mine.

I know that the broken-open container

of your Mother's Heart

has room for us all:

for the women of Iraq and Rwanda,

Afghanistan and Bosnia,

Darfur and Burma,

Palestine and Israel,

whose innocent children are sacrificed every day

as victims of these senseless wars;

for parents in Los Angeles and Albuquerque,

London and Buenos Aires,

whose sons and daughters are killed in sudden car wrecks,

or die of lingering cancers,

or wrestle with the demons of addiction,

or languish in prison systems

specially designed to breed violence and hatred.

Your own sorrow has rendered you invincible, Mother.

I cannot bear these losses alone.

Please share them with me.

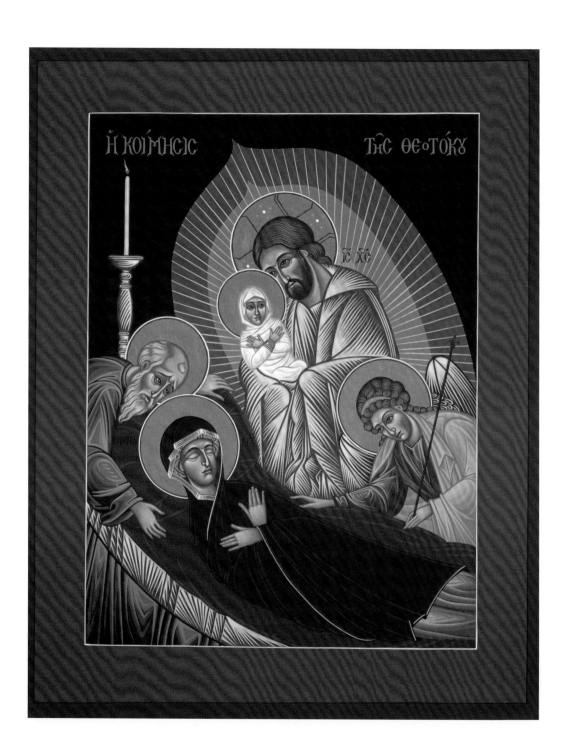

THE DORMITION OF THE MOTHER OF GOD

Blessed Mother,

God-Bearer,

who stayed awake scanning the night

for signs of danger to your children

while we rested,

it is your turn to sleep for a while.

I release you into the arms of your own divine child.

You swaddled and soothed the light of the world

and then accompanied him all the way to the threshold of death.

Your time has come to be held by God.

Let me be brave, Holy Mother, and stand up while you rest.

Help me to be steady and whole

and ready to carry my share of suffering and beauty,

of radical mystery and unexpected grace.

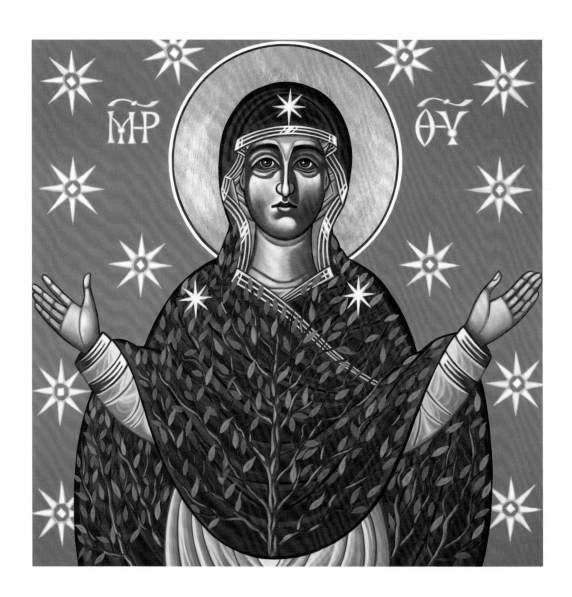

MOUNT SINAI THEOTOKOS, THE BURNING BUSH

Mother of Fire,

wrapped in living flame,

you remain unharmed.

Like the burning bush the exiled prophet came across

while tending his flock on Mount Horeb,

you blaze with the word of God

and are not consumed by it.

Instead, you blossom.

In your radiant presence,

all I can do is take off my sandals

and fall to my knees in awe.

Mary, please give me the courage

not to turn away from the pain of this life,

but to be still inside the heart of the fire

and allow it to transfigure me.

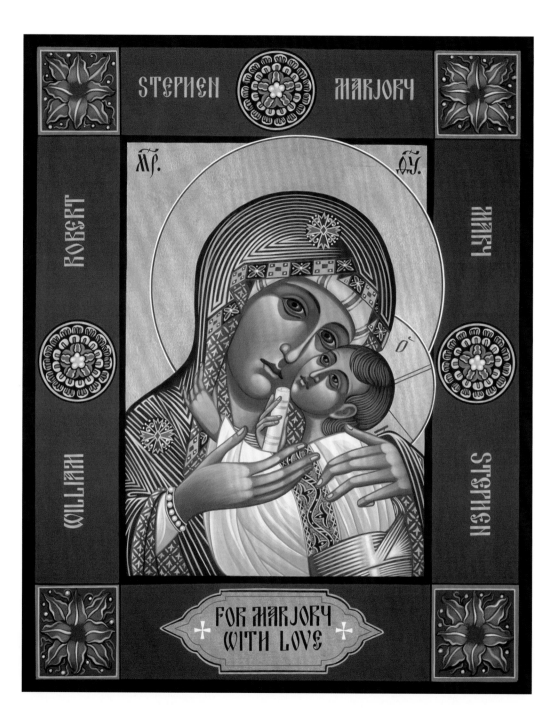

STEPHEN · MARJORY · ROBERT · MARY · WILLIAM · STEPHEN

FOR MARJORY WITH LOVE

MOTHER OF FAIREST LOVE

Mother of fairest love,

of holy awe,

of perennial wisdom,

and of hope in the face of despair,

teach me to love as you love:

unconditionally.

Transmit to me the secret code

that unlocks my opinionated mind

and sets me free to play

in the open fields of the heart.

Holy Wisdom,

you are the breath of the Holy One.

You are a radiant emanation of his glory.

You hold up a mirror to his goodness,

and your own eyes reflect his eternal face.

As I empty myself of myself,

enter me now,

and make me an intimate friend of God.

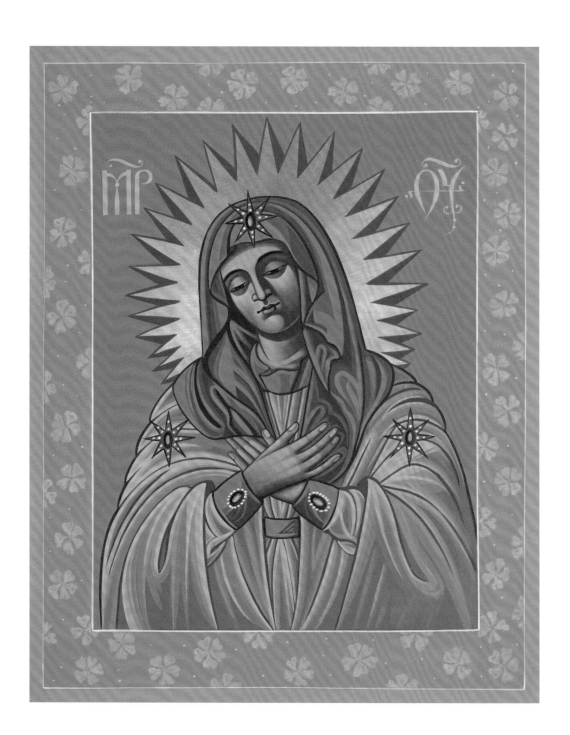

UMELENIE, HOLY MOTHER OF GOD, JOY OF ALL JOYS

Great Mother of us all,

we invoke your boundless joy.

Where hearts have been contracted with disappointment,

you expand them and teach us to love again.

We had begun to wonder if an endless winter

had descended on our souls.

Now you lift the bank of cold,

Blessed One,

and everything bursts into bloom.

Yet this harvest is not meant to be scattered.

Teach us to contain the treasures in our spirits

and not spill our life-force carelessly.

Let us hold the light of the world

like a secret

until the time comes to release it

into the hands of the waiting world.

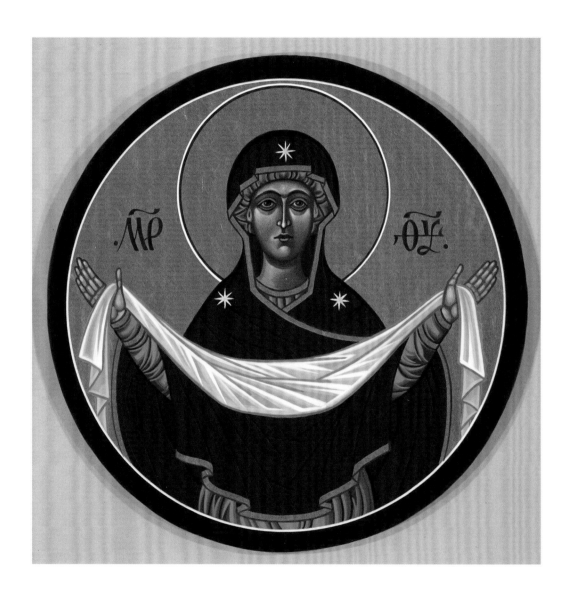

THE HOLY PROTECTION
OF THE MOTHER OF GOD

Mother of Mercy,

if I stay awake all night,

vigilant and grateful,

will you drop your protective veil

over my vulnerable heart?

I cannot control the world around me;

I can only be faithful to my own deepest truth.

Wrap me in your pure white cloak of devotion, Mary,

so that I can remember that my sole task

is to praise the God of Love.

Cover me in your burial shroud

as I die to my false self,

to be reborn

as a living example of peace on earth.

Infuse me with the tincture of your tears,

so that I may face every challenge

with a tender and courageous spirit.

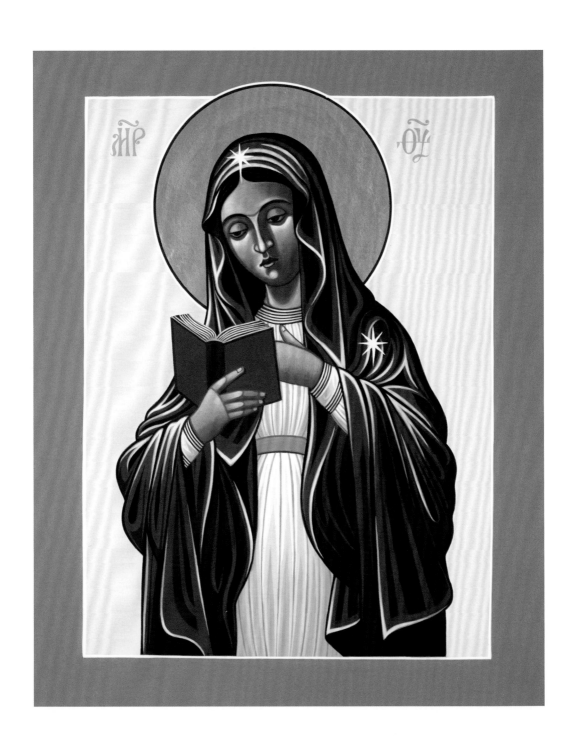

MOTHER OF THE INCARNATE WORD

Pregnant with the Word of God,
you slip into prayer.
You do not simply read sacred scriptures;
you allow yourself to become fully absorbed
in the perennial wisdom they illumine,
and then you embody it.
Blessed Mother,
innocent bride of the Absolute,
You say Yes to the Holy Spirit
and are quickened with the divine teachings.
Mary, Mother of the Word made flesh,
teach me to be a true contemplative.
Let me leave my scattered thoughts behind
And enter the secret refuge of my soul.
Let me carry the Prince of Peace in my own womb,
giving birth to truth
with every word I utter.

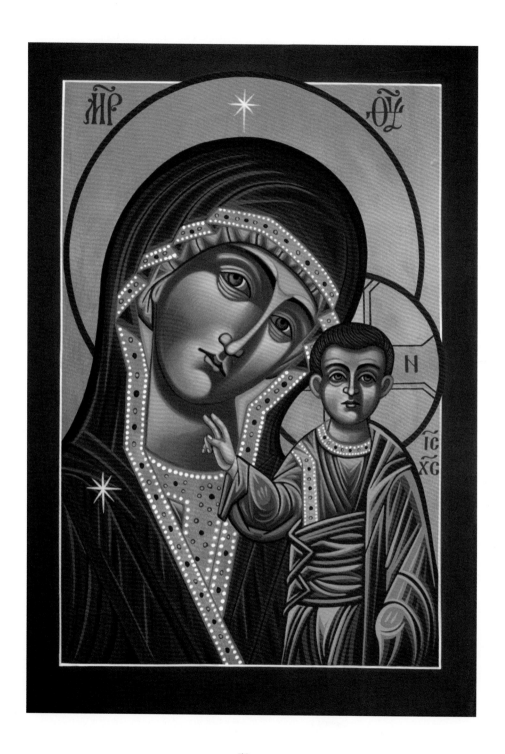

OUR LADY OF KAZAN

*F*eminine face of the Holy One,
you are known by many names,
but all of them mean Mother.
You have appeared since the time of our earliest ancestors
as the embodiment of mercy and compassion.
You have been celebrated in song and scripture
as the essence of Sacred Wisdom.
You lived a fully, deeply human life,
and this humanity is what helps us feel connected to you.
Do not hide your face from us now.
This world is yearning for your Mother-Love.
Show our leaders how to guide us
with respect for our dignity and well-being.
Teach us to love one another
with boundless patience
and unbridled joy.

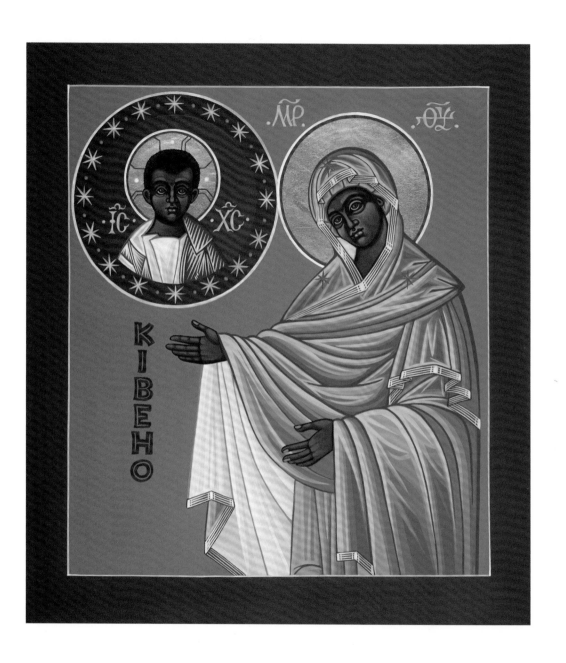

IN KIBEHO, MOTHER OF THE WORD

Ancient Mother,
Black Madonna,
Dark Lady of Birth, Death, and Rebirth,
you speak out from the heart of the world:
from the glowing windows of distant temples
as I walk through the night;
in secret caves tucked into mountainsides
whose names I cannot pronounce;
in city streets and private academies;
among the poorest of the poor
and the keepers of the jewels.
Your message is uncompromising:
Brother, stop hurting your brother.
Sisters, put down your weapons.
Neighbor, open your door to your neighbors.
Wake up, stand up, wash yourselves
and look up attentively.
We must dedicate ourselves to prayer,
we must develop in us the virtues
of charity, availability, and humility.
Teach me, merciful Mother,
to make peace with every breath.

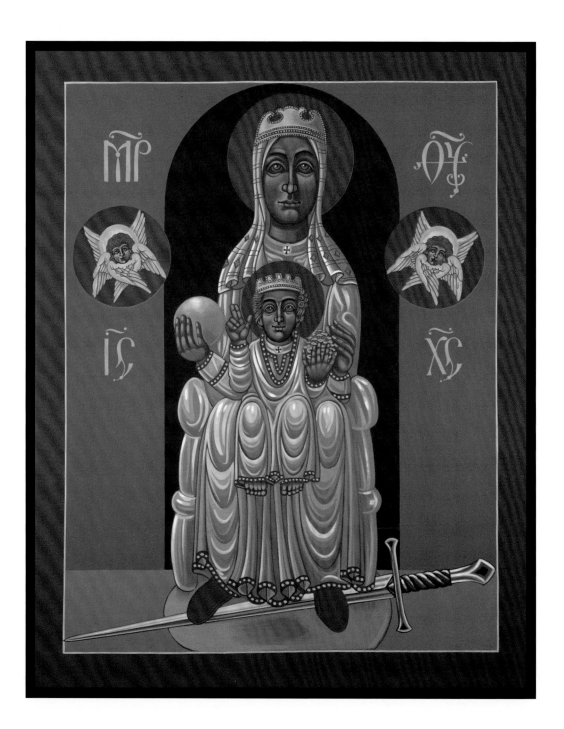

LA MORENITA DE MONTSERRAT

I am dark, daughters of Jerusalem, and I am beautiful!
Black Virgin,
Mother of us all,
teach me to see the beauty in the Mystery.
Help me to relinquish my need
to figure out the Holy One
with the feeble tool of my intellect
and instead encompass divine truth
with my open heart.
I am tired of fighting for control.
I am ready to lay down my sword
at your gentle feet, Blessed Mother.
Give me the courage to enter the secret cave
where you hold the Redeemer nestled in your loving arms.
Your face radiates from the gaze of the angels that surround you.
Let me find my own true face reflected there.
Then I will be able to sing with the Bride,
Do not see me as only dark: the sun has started in me.

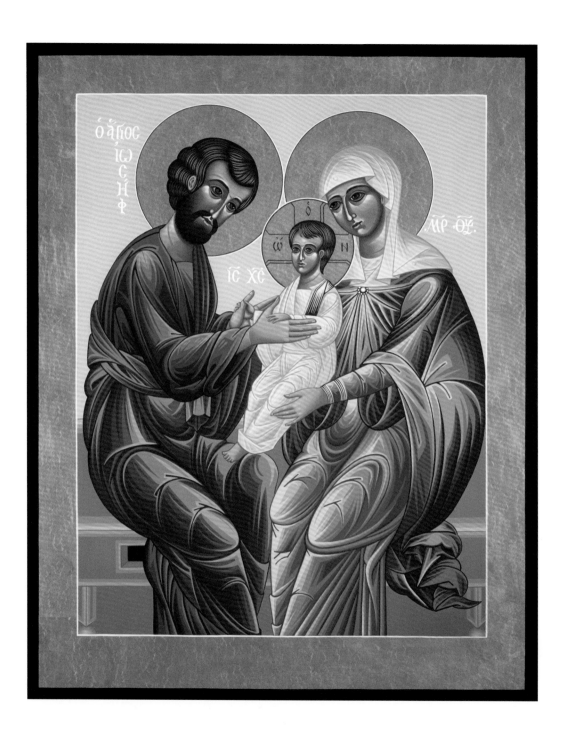

· 58 ·

LA SAGRADA FAMILIA

Blessed Mother, bless us.
Bless our family.
Let us embrace each new child
as the light of the world.
May I, as a mother like you, Mary,
generously share the intoxicating love of this little one with my partner.
And may I, Mary, as a father,
unwrap the secret covering of my own feminine heart,
and tenderly receive and protect this baby being offered into my care.
Mother of God,
show us the way to balance adoration of our child
with cherishing of one another.
May our relationship be a sanctuary
where we find rest, renewal, and radical wonderment.

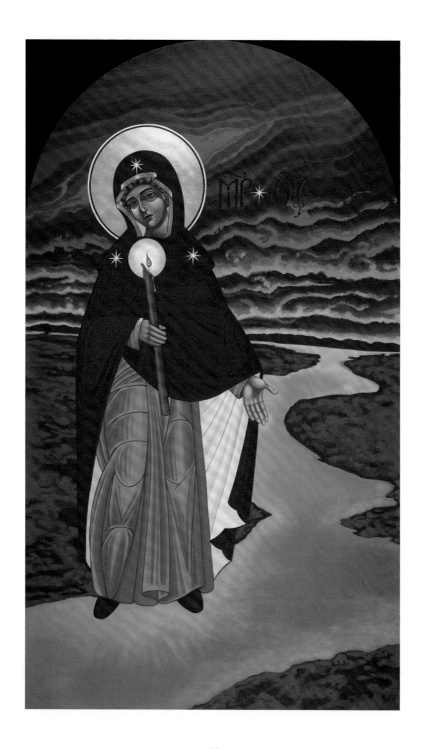

OUR LADY OF THE LAKE

Walking on water,

you come carrying the light of the world, Blessed one.

You part the tempestuous tide of my life

and shine your candle into the dark corners of my mind,

banishing the shadows that have collected there.

I have lost my way, radiant Lady,

lured by the false lights of the mundane world.

I need to return to the garden of my soul.

You are the Morning Star, sweet Mother,

and I welcome you.

I am ready to rise from the darkness

and greet this new day.

Help me to shed the burdens of my past

and begin again,

galvanized with faith,

cleansed with light.

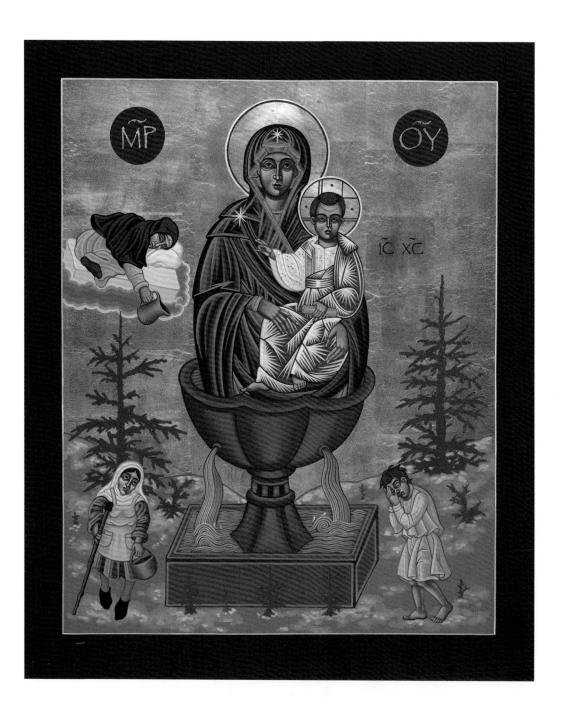

MOTHER OF GOD, LIFE-GIVING SPRING

Bright Madonna,

my soul thirsts for the living waters.

Illness and pain have brought me to my knees.

I come to you broken, and broken open.

Pour your grace into this shattered vessel

and help restore me to wholeness.

Blessed Mother,

you are the life-giving fountain

that endlessly springs from the heart of the Holy One.

We who are sick in body and soul

make our way through the darkness

to the place where you rise, radiant, from the earth,

infusing our weary spirits with the waters of life,

and we are healed.

Now, please help us to find these sacred streams

within ourselves,

so that we may be a source of healing for others.

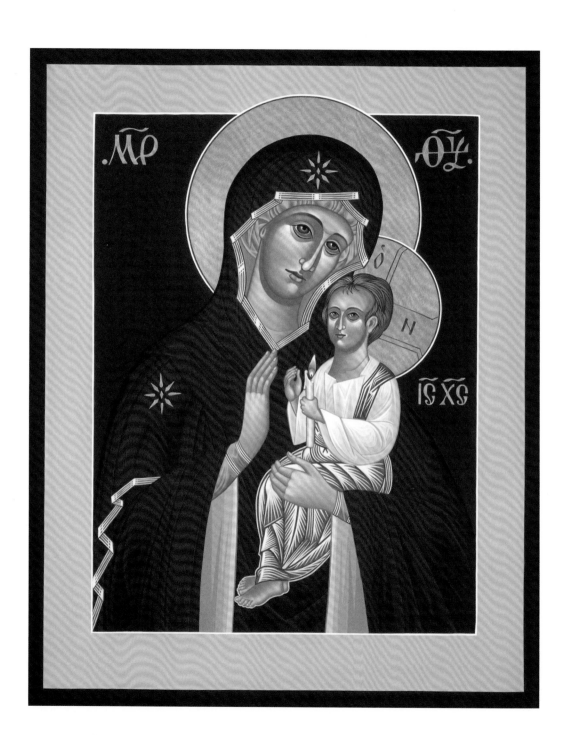

MOTHER OF GOD, LIGHT IN ALL DARKNESS

Mother of God,

Light in All Darkness,

the candle in my heart has blown out

in the storm of suffering that has come into my life.

When I most need the comfort of community,

I am feeling most alone and misunderstood.

Not only must I endure the burden of my malady

and live among the wreckage of my broken heart,

but I am persecuted for my suffering

by those who presume to judge me

as being the architect of my own circumstances.

As you protected the flame

held by the small hands of your child, Mother,

rekindle the fire of love that once burned in me.

Let me embrace my own vulnerability and woundedness,

and offer them as gifts

to a hard-hearted world.

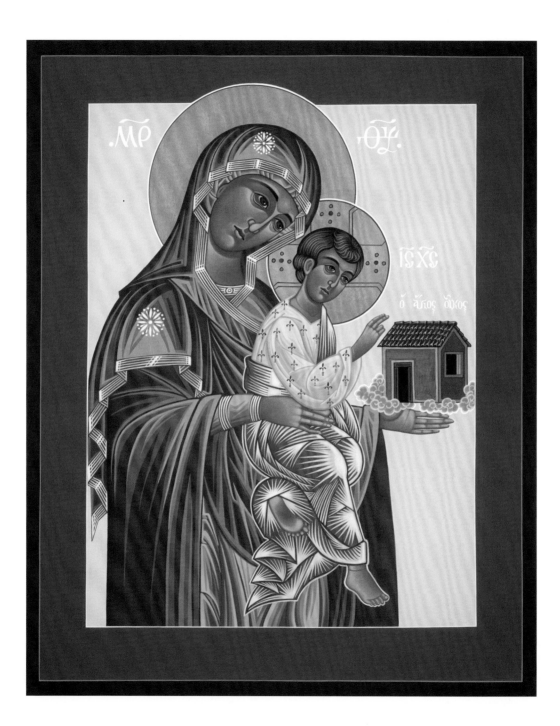

OUR LADY OF LORETO

Blessed Mother,

Tower of Ivory,

House of Gold,

help me to make of my body a temple for the Holy One.

Gate of Heaven,

Morning Star,

help me to sanctify belly and breast,

that I may be sustained and offer sustenance.

Queen of Angels,

Queen of All Saints,

help me to open the palms of my hands

and toughen the soles of my feet,

that I might use the strength of my limbs

for the glory of God.

Blessed Mother,

Vessel of Peace,

may I cherish myself enough

to throw open the doors of all that I am

and invite the Divine to find refuge in me.

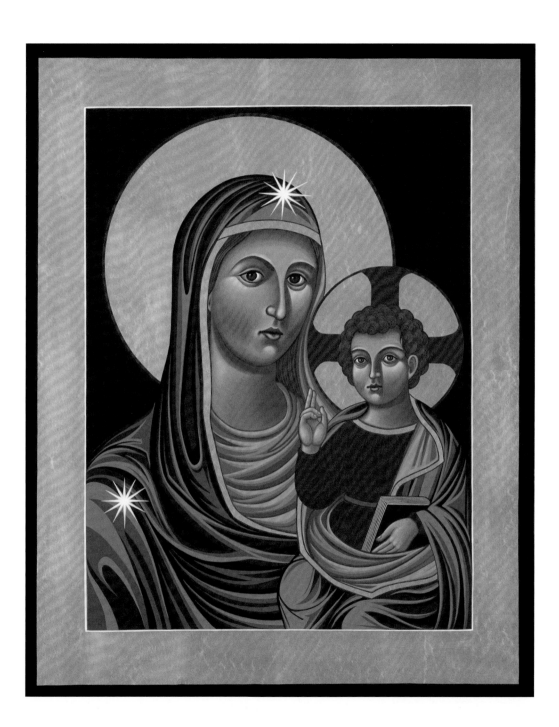

MADONNA DELLA STRADA

Blessed way-shower,
show me the way.
Clouds of confusion obscure my path.
I am immobilized by fear of making the mistakes
I have made so many times before.
Something inside me keeps luring me down a road
that leads to violation of my own sweet self.
Help me, Blessed Mother,
to make choices that honor my soul
and glorify my Creator.
Like my Native brothers and sisters,
teach me to walk the Beauty Way:

Beauty before me,
beauty behind me,
beauty all around me.
In beauty it is begun;
in beauty it is done.

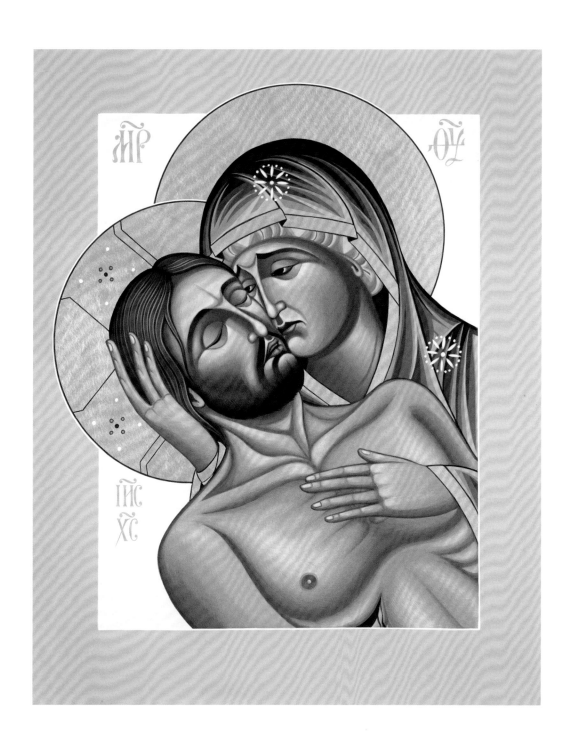

MOTHER OF GOD OF MAGADAN

Broken-hearted,

open-hearted,

brave-hearted Mother of God,

I weep with you.

You take into your arms

those who have given up everything for the Truth.

All over the world,

throughout the ages and right now,

the blood of the martyrs is spilled:

in prison camps and inner cities,

on battlefields and in hospitals,

in churches and synagogues and mosques;

they bleed for justice for the voiceless,

for peace on earth,

for the freedom to praise,

for the rights of all beings to live in dignity;

they bleed for the bleeding earth.

And you, Blessed Mother,

receive them all and weep for them.

Each one is your own holy child.

Each sacrifice is a sword in your own heart.

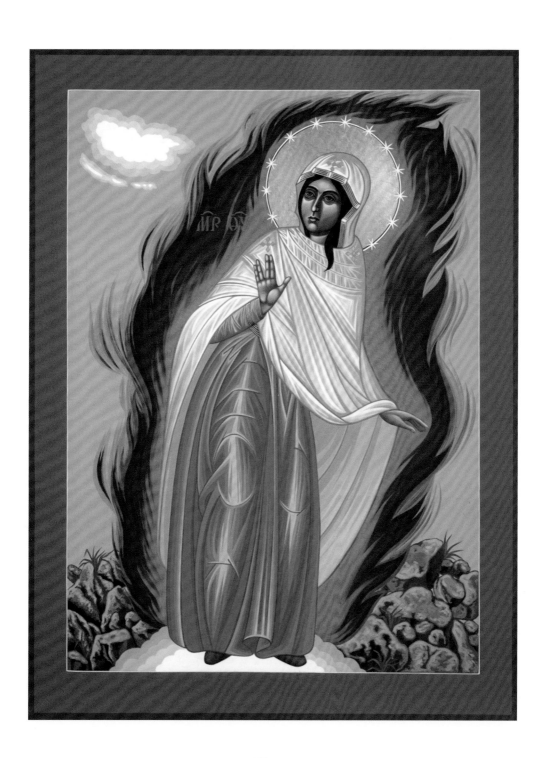

OUR LADY OF MEDJUGORJE, THE BURNING BUSH

Divine Mother,

Living Flame of love,

ignite my heart with the fire that blazes in the night

and never consumes the fuel that feeds it.

Let me be the fuel, Blessed one.

You who led my ancestors through the wilderness,

light my way home to the place where my Beloved is waiting for me.

Queen of Peace,

whisper your healing secrets in my ear

and I will share them with the whole world,

so that in the circle of my own blazing heart

the fighters will lay down their weapons

and take each other into their arms.

Holy Prophet,

you who burn with love for the Holy One,

I am ready to meet you in the sacred fire

and be transfigured by love.

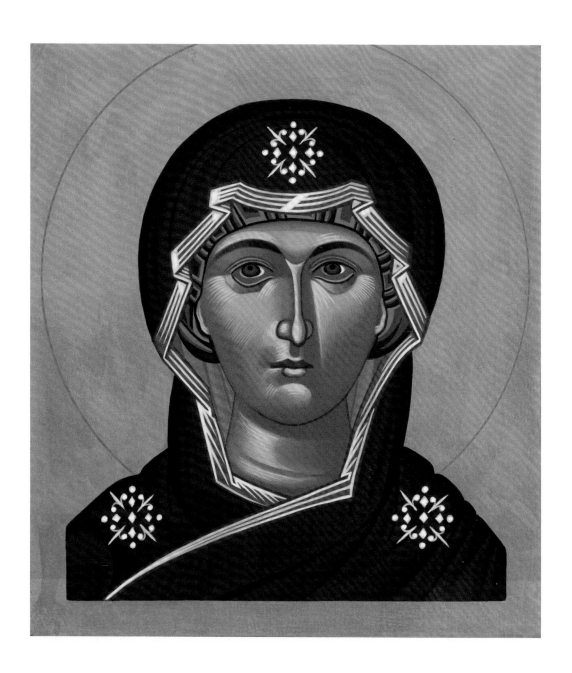

MOTHER OF GOD, MYSTICAL ROSE

Sweet Mother,

you are a garden encircled by the fires of love.

I am not afraid to enter.

You are the fragrance of the Holy One.

I breathe you.

You are abundance,

clarity,

boundless generosity.

You are also the thorn that pierces the heart,

the blossom of blood,

and the tincture that soothes the pain.

Beloved of the Beloved One,

you are the resting place for the Divine.

As you once blessed a humble Aztec farmer

in the heart of winter

where nothing earthly grows,

you spread a never-ending miracle of roses at our feet.

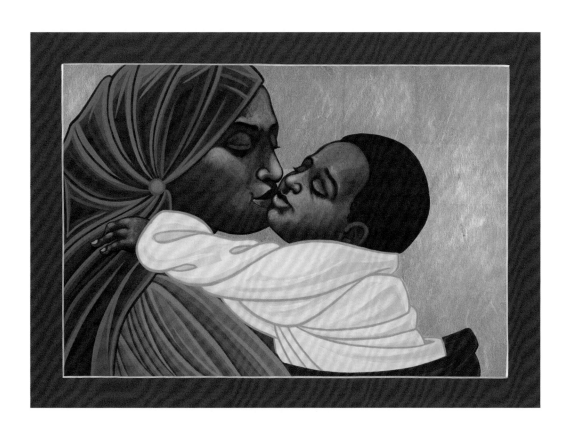

MOTHER AND CHILD OF KIBEHO

Sweet Mother of the universe,
enfold me in the circle of your unconditional love.
I am prepared to be adored, Mother.
I have set down the burdens
of self-recrimination and self-righteousness
and reach freely for you now.
Lift me from the illusion
that I am in charge of the world.
Lift me from the anguish
of separation from my source.
Lift me from my isolation and weariness.
I take refuge in your kiss,
the universal kiss
that transfigures the heart of humanity,
renewing and revivifying us,
so that, blessed and well-loved,
we may love and bless all that is.

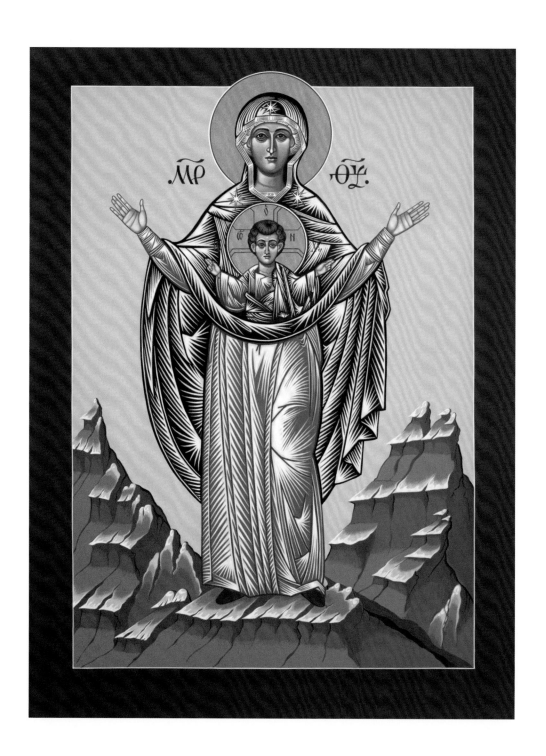

OUR LADY OF THE NEW ADVENT, BURNING BUSH

Blessed Mother,

the world is burning.

We call upon you once again

to say Yes to the fearsome grace of the Holy Spirit,

and allow yourself to be quickened with the Divine Word.

Come down from the mountain

where you have stood vigil,

and deliver the Hope you carry

into the empty container of these troubled times.

I will meet you halfway, Holy Queen.

I will do my part,

and climb the rocky reaches of the wilderness

to stand beside you.

Together we will usher an age of peace and mercy

back into the heart of creation.

Together we will step into the flames

and we will not be consumed.

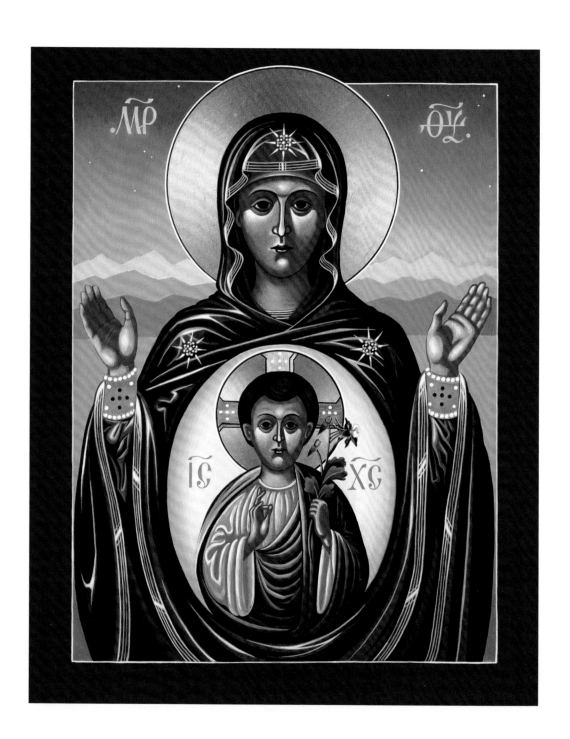

OUR LADY OF THE NEW ADVENT, GATE OF HEAVEN

Gate of Heaven,

you are round and open,

beckoning.

Your hands are raised in blessing:

blessings rain down on our uplifted faces.

Mother of the All,

you contain the answer to our deepest longings.

I come to you with the cup of my soul empty.

Fill me with hope for a new world,

a world of pervasive peace and unmitigated justice,

where swords are hammered into plowshares,

and our leaders sow vegetable seeds.

Lady of the Mountain,

I have struggled to your summit.

The ascent has been harrowing,

but I have grown strong on my journey.

Now I see the world as you see it,

broken and beautiful,

flawed and perfect.

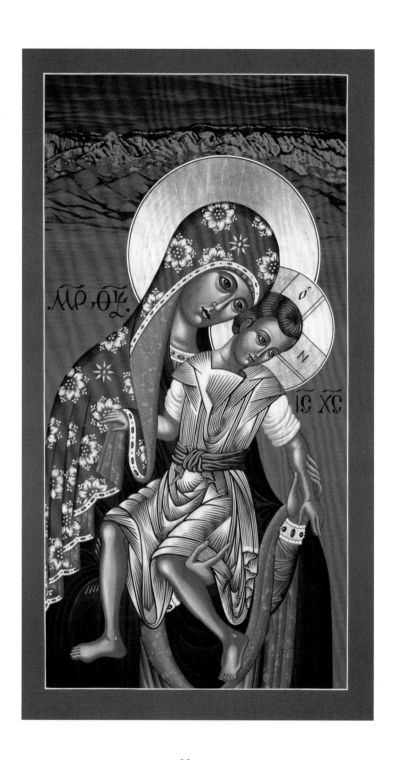

NUESTRA SEÑORA DE LAS SANDIAS

Madre Mia,

you gaze down from the summit of the mountain you have ascended

and call out to us:

"The journey IS the destination. Come."

I have confused the path home to my Beloved

with just another task on my to-do list.

I am in such a hurry to cross it off.

You remind me that the Divine is everywhere always,

and that all I have to do is open my heart

and welcome her:

that she shines from the setting sun

as it washes the face of the mountains with light;

that the blood of Christ

seeping from all the broken seams of my life

is healing, not punishing;

that my weary legs are growing stronger as I climb upward

and my bleary eyes are becoming clearer as I make my way deeper inward

to that secret place where the Mystery is waiting to receive me

with the wide open arms of love.

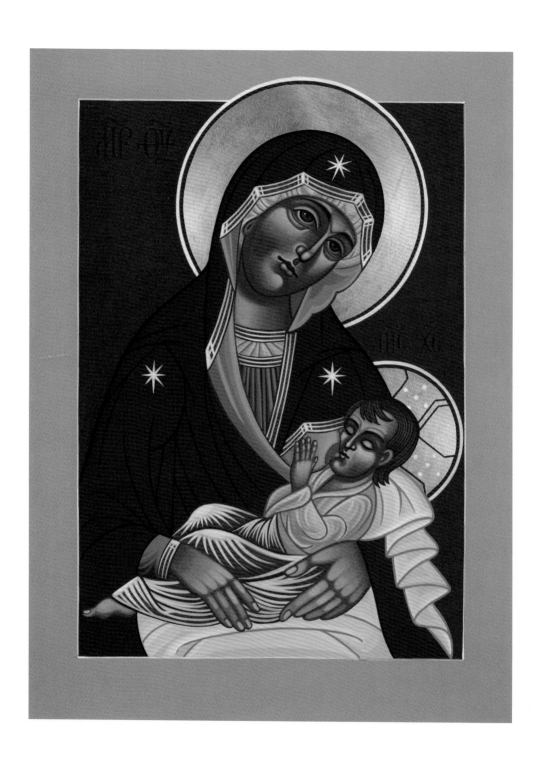

NURSING ICON OF THE MOTHER OF GOD

Holy Mother,
you nourished the Word of God from your own breast.
In the garden of your tender love
he grew strong enough to bless the whole world.
Even as you poured out your love for the Divine
you were replenished tenfold with Divine Love.
Let me learn to give of myself
with this depth of sacred surrender.
May I know at last the simple joy that comes
from discovering my true task in this life.
And may that sweet elixir fill me
and spill over the cup of my life,
to nurture and affirm everyone I touch.

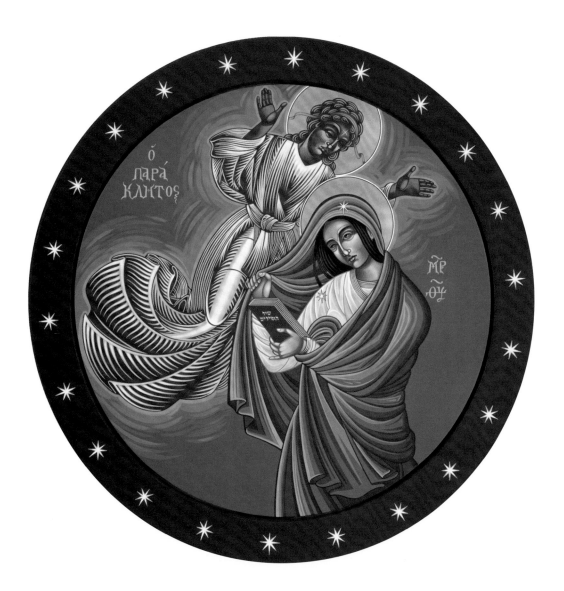

MOTHER OF GOD OVERSHADOWED
BY THE HOLY SPIRIT

Beautiful, blessed hollow reed

through which the Holy One poured himself into the world,

please ask the Divine to shape me into a vessel for his love.

Remind me that the Beloved longs for union with me

as fervently as I yearn to return to him.

As the Father sent his Holy Spirit to surround you,

the Mother,

and quicken you with the Word of God,

his Son,

so let me open myself to the Mystery.

May my body become a conduit for the sacred

to incarnate here on earth.

May I learn to exalt in the ordinary moments of my life,

and embrace God everywhere,

in everything,

always.

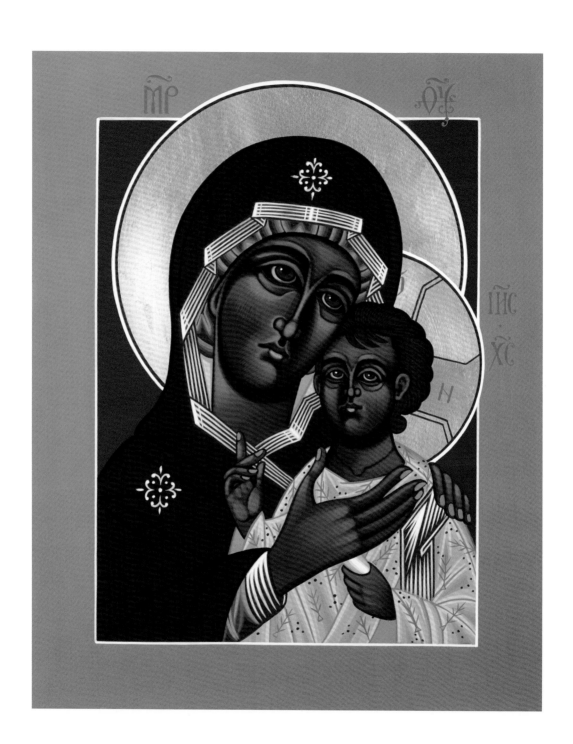

THE PETROVSKYA ICON
OF THE MOTHER OF GOD

Holy Brown Madonna,

Mother of all people who live in harmony with the land,

help me to unclench my fist and release all my wanting.

Instead of clinging to cars and clothes,

gadgets and games,

let me find the treasure in the crescent moon

floating in the face of the night sky.

Rather than seeking congratulations for my own accomplishments,

let me discover the grace of praising you.

Blessed One, sometimes I forget

that I am a small shining thread

in the radiant cloak of creation

and I mistake myself for the king.

Help me to reconnect with the web of all life,

and take my rightful place

as a child of the earth, my Mother.

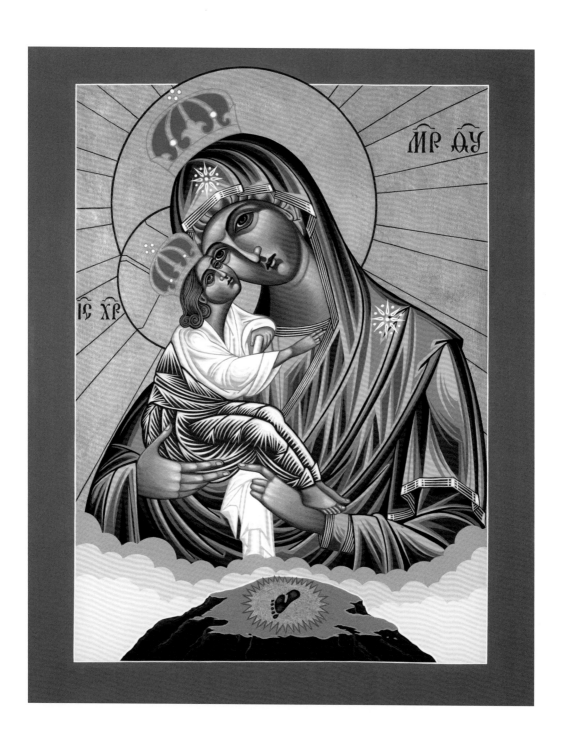

OUR LADY OF POCHAEV

Queen of Compassion,
I see your footprint everywhere now.
Your presence is fire,
the roaring flame of justice,
where those who have no voice
cry out in silence and are heard.
You wipe away the tears of the forsaken.
You rise from the mists of holy mystery,
limpid and radiant,
crowned with the authority of the Holy One.
You carry the Prince of Peace.
In your wake the living waters rise and flow
over the parched wilderness of our souls
and we are revivified.
Blessed Mother,
let me walk lightly on this earth.
Let my footsteps leave no trace of harm.
May your loving touch be my guide.

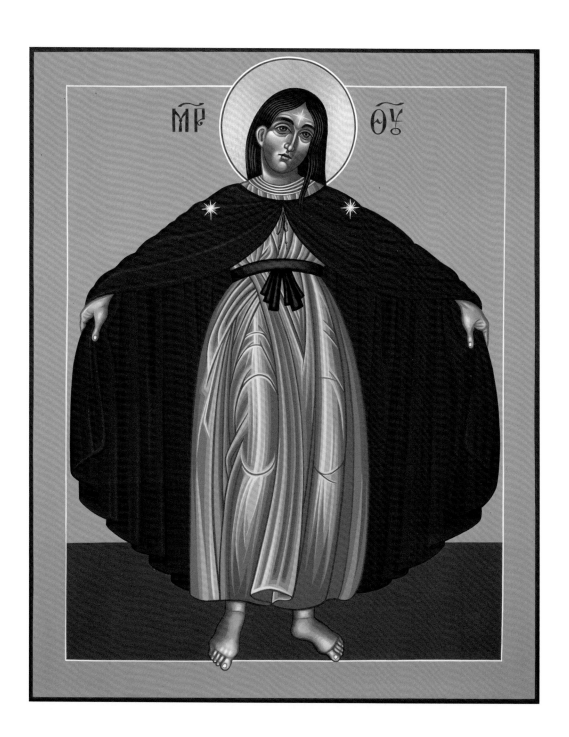

MARY OF THE MAGNIFICAT, MOTHER OF THE POOR

Holy Mary,

you remind me that this emptiness will be filled,

that this struggle will end in peace and justice.

But I am too busy thinking about lack

to believe in abundance.

I work all day and worry all night,

just to bring home a few eggs,

a stack of tortillas,

a bag of oranges.

Then I get up and do it again:

a few gallons of gas for a car that barely runs;

a disconnect bill from the electric company;

an infected tooth.

My children feed on my stress like wild animals;

they spin out of control.

Blessed Mother,

you who nurtured the Holy One

inside your own humble body,

give us refuge in the folds of your cloak.

Restore my unraveled faith.

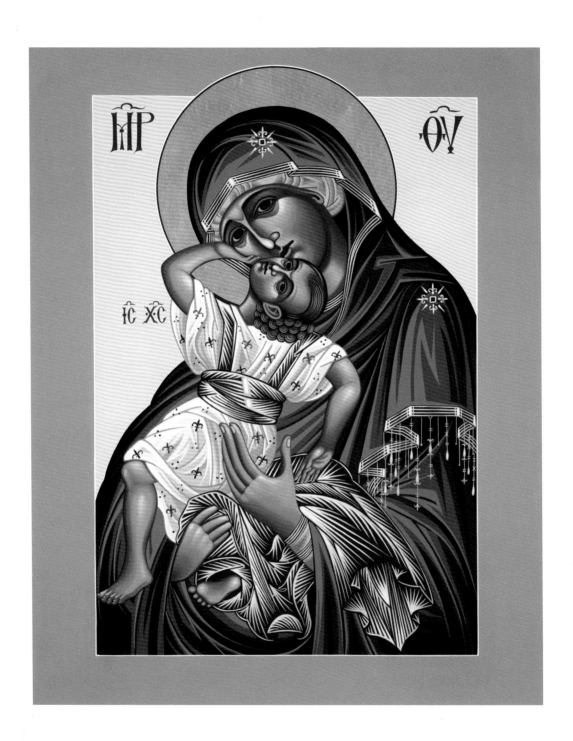

MOTHER OF GOD REJOICING

Mother of God,

rejoice with me.

In the midst of the petty trials

and the profound sorrows of this life,

let me catch a glimpse of your face

and dissolve into laughter.

You who "come across the waters,"

float through the rushing streams of my preoccupations

and set my heart free.

Let me remember that what matters

is not the laundry I have to fold,

but the gurgling of the baby speaking his own new language,

not the bank account that will not balance,

but the miracle of the dragonfly landing on my wet shoulder

as I climb out of the river on a summer day.

Like the tender hand of a child

who spontaneously reaches to comfort his worried mother,

let me lightly carry the suffering of the world.

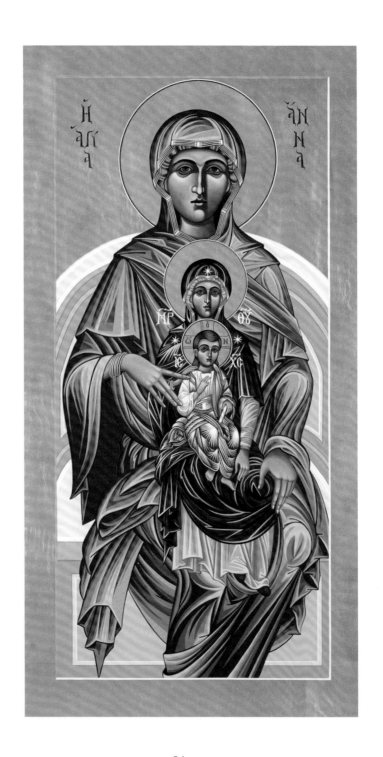

THE SHRINE OF SAINT ANNE

Holy Grandmother, Anne,

Mother of Mother Mary,

tell me a story.

Let me curl up at your feet,

beside your warm hearth,

and listen.

I am ready to receive the wisdom of my ancestors.

You who carried my blessed mother

and served as midwife for the birth of my holy brother,

tell me what it was like to bear witness

to the unfolding miracle of light

as it spilled from womb to womb

into the darkened world.

I want to know which psalms you chose

when you taught your daughter to read,

how the air felt the morning the Christ Child was born,

what herbs you would pick,

if you were I,

to brew a healing broth

for this troubled world.

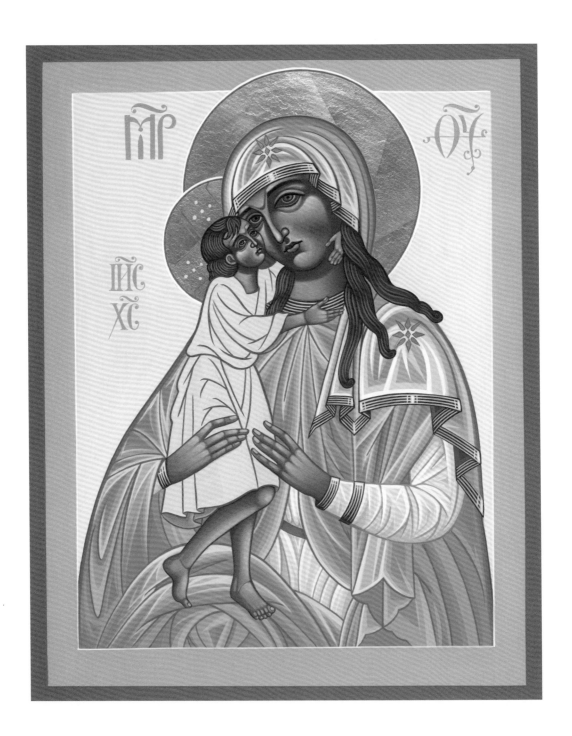

MOTHER OF GOD, SEEKER AFTER THE LOST

Sweet Mother of all,
someone I love is slipping away.
He has lost himself in the wilderness
of substance abuse and self-hatred.
I see him wandering to the edge of an abyss,
and I am powerless to call him back.
Call him back, Blessed One.
You, who travel in an instant to the ends of the earth
to seek the lost and bring them home,
please bring him home to me.
Let him know that there is a pot of soup on the stove,
warm blankets on the bed,
and that all is forgiven.
Remind him that he is worthy, Mother:
worthy to be healthy and whole,
worthy to be loved.

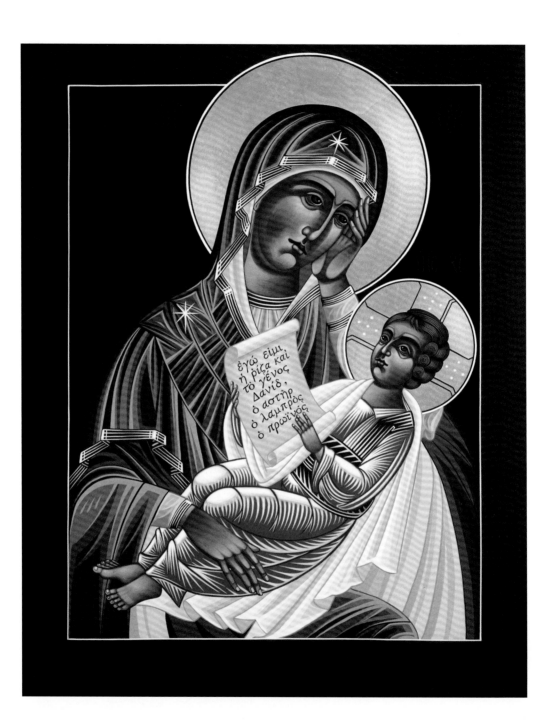

ἐγώ εἰμι,
ἡ ρίζα καὶ
τὸ γένος
Δαυίδ,
ὁ ἀστὴρ
ὁ λαμπρὸς
ὁ πρωϊνός

MOTHER OF GOD, SOOTHE MY SORROWS

Mother Mary,
you who know suffering
in every fiber of your being:
my heart is breaking.
Unbearable loss has swept through my life like a tsunami
and crushed my soul.
From this ravaged wasteland, Blessed One,
I reach to you for solace.
In my pain I have been tempted to strike out.
I want to blame someone for this catastrophe,
and my anger is nothing but a searing coal in my belly,
consuming me from within.
Yet when I gaze on your sweet face, Mary,
and witness the tenderness of your grief
and your love,
I glimpse a bigger picture,
and my heart quiets.
I strive to remember the Divine Word:
Judge righteous judgment, and act mercifully and magnanimously.

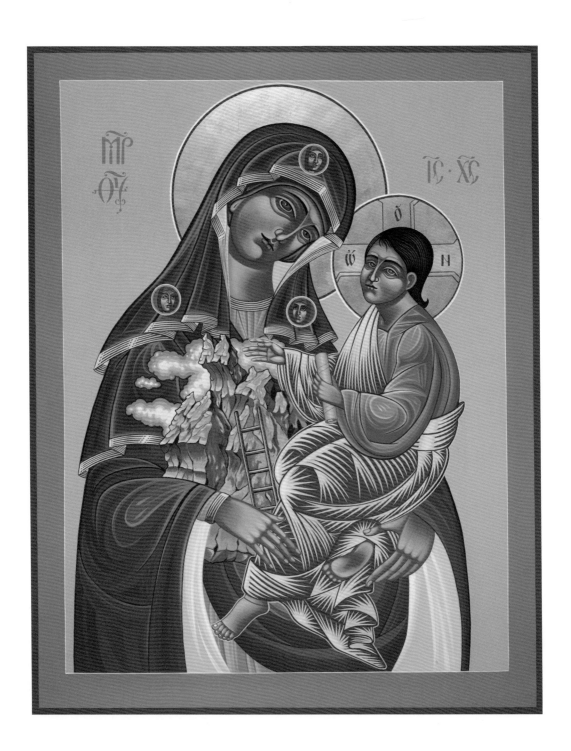

MOTHER OF GOD, STONE BROKE LOOSE FROM THE MOUNTAIN

*I*ndwelling Spirit of the Divine,

may your sacred power roll down from the mountain

and transform the landscape into a place of peace.

As Shekhina,

the mist that guided our people in the wilderness,

show us the way to freedom.

And as Shekhina,

the pillar of fire that led them safely through the night,

lead us to truth.

Like the mighty stone that crushed the cruel dynasties, Blessed Mother,

teach us to disarm the false powers of this world

with our non-violent resistance.

Drop down the ladder of your love,

which connects the heavens with the earth,

and remind us of our true home in God.

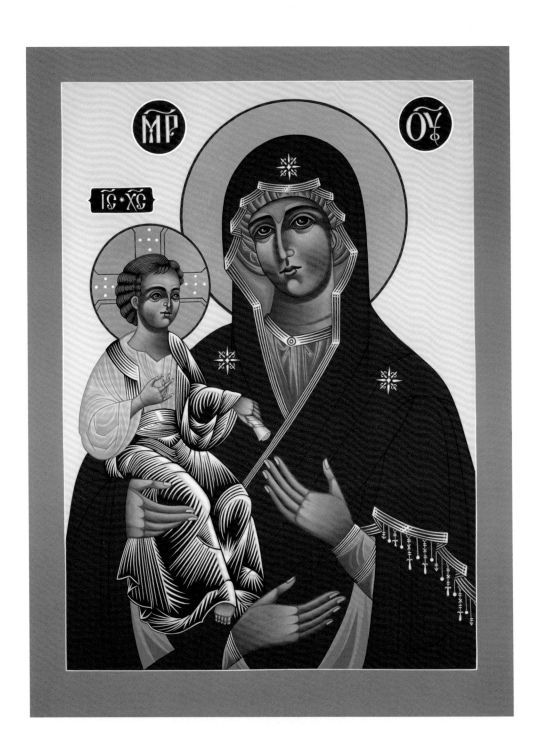

THE THREE-HANDED ICON
OF THE MOTHER OF GOD

Two hands are not enough

to reach out and feed this world.

Mary, Mother of the hungry, let me help you.

Bolstered by your miraculous generosity

I am ready to extend my own hand to those in need.

I do not act alone.

When I fuse my strength with yours

there is no limit to my capacity

for alleviating suffering.

Mother of God, I know the Holy One

to be both form and formlessness,

beyond the beyond,

and yet fully here,

right now.

In the pure light of all that is

he has no boundaries.

But inside this wounded world

he needs me.

Whatever I do for the least of brothers and sisters

I do for him.

Do not let me collapse into abstract concepts.

Help me recognize the face of the Divine

in everyone I encounter.

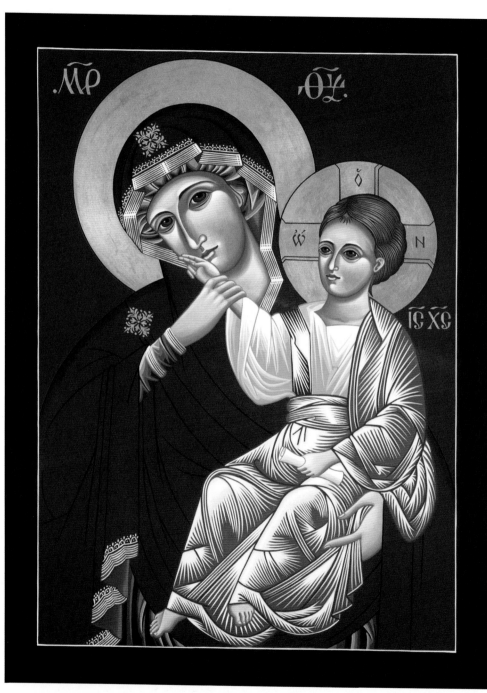

MOTHER OF GOD VATOPEDI

Mother of Consolation,
help me to let myself be consoled.
I hold it all together, Blessed One.
I have convinced myself that it is up to me
to keep the airplane aloft with my own breath,
that I am the only one capable
of baking bread and scrubbing floors,
that it is my responsibility alone
to alleviate the sorrow
in the heart of every single person I know.
But I have forgotten how to weep, Tender One.
Teach me to reach out to the ones I comfort
and ask for their comfort.
Let me feel the tender touch of the Holy One
on my cheek when I wake in the night,
weary and frightened.
Help me to be vulnerable and soft now,
broken open and free.

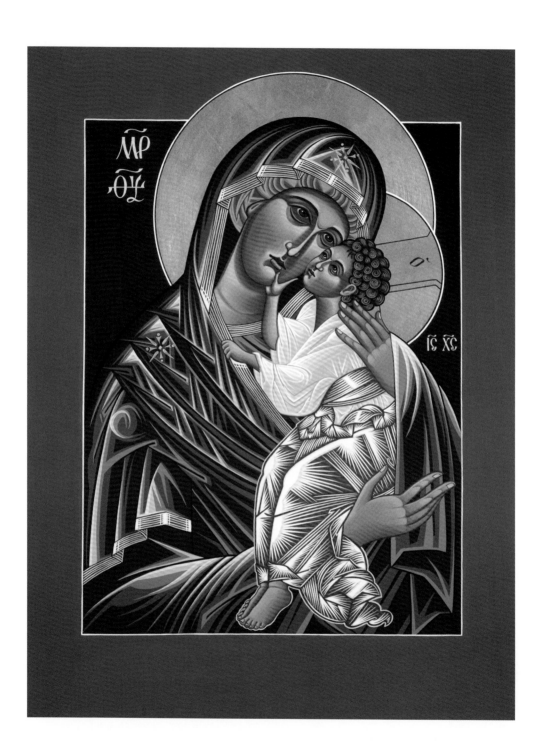

VIRGIN OF TENDERNESS OF YAROSLAVL

Virgin of Tenderness,

disarm my heart.

Let me melt in the warmth of your loving arms.

Let the gentleness of your caress

penetrate the hardened seedbed of my soul

so that the living waters may flow into me.

May I germinate, sprout, and flower

with the spirit of the Holy One

that has been planted deep inside me.

Sweet Mother of God,

I take refuge in the soft folds of your cloak.

I press my face against your face.

As long as I am in your embrace

there is no need to protect myself

against the pain of the world.

I surrender to your healing touch.

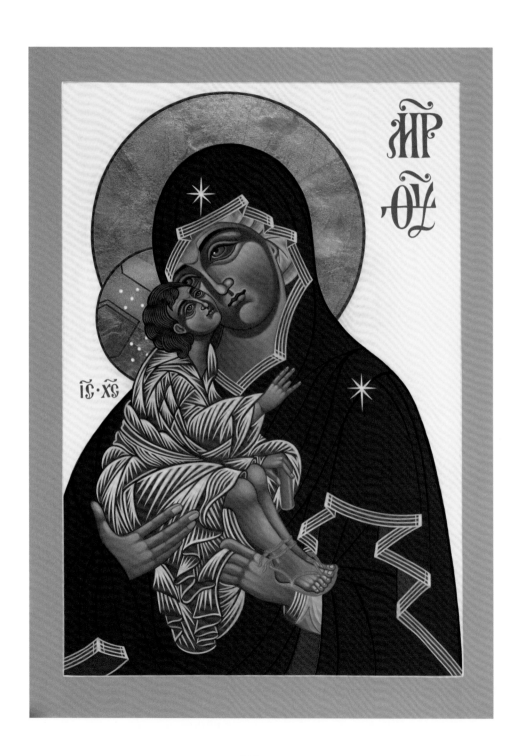

MOTHER OF GOD, VIRGIN OF THE DON

Sweet Mother,

River of Light,

draw me into your tender embrace.

I weep for the pain of the world:

the suffering of innocent animals

at the cruel hands of humans;

the anguish of mothers

whose sons and daughters are ordered into battle

by imperious leaders in remote offices;

the ruination of the atmosphere

and the disappearance of vast stretches of wilderness.

I know that you weep with me,

that when I reach for you, Blessed Mother,

you receive me

and mingle your tears with mine.

Together we can hold the broken heart of the world

and keep it safe.

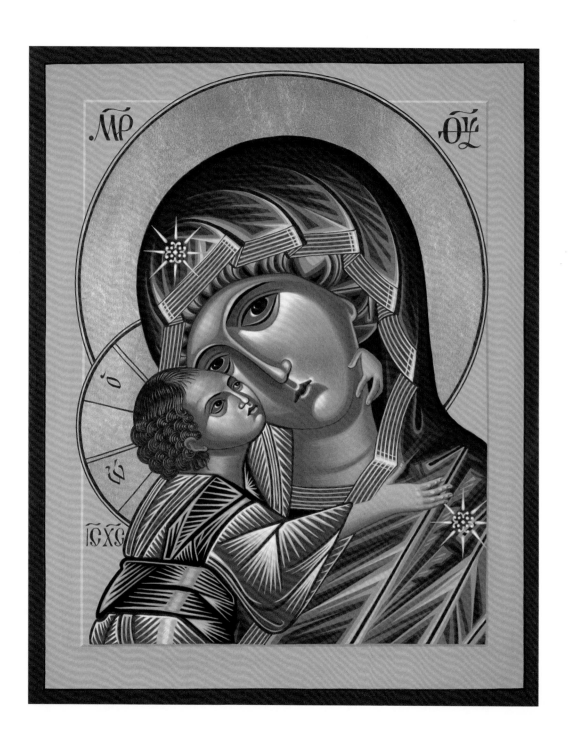

OUR LADY OF GRACE, VLADIMIR

Holy Mary,
filled with grace,
filled to overflowing with grace,
you whose grace spills
like a never-ending mountain spring
into the troubled valleys of lives,
be with me now.
The wonder has drained from my heart.
Where once I saw God in everything –
in a leaf quivering on an aspen tree,
in the smile on the teller's face as she cashed my modest check,
in the way bread dough rises on a sunny windowsill –
now even the most sacred prayers sound like meaningless mumbles.
Help me rekindle the awe that infuses your countenance,
the fleeting joy that comes at the inevitable price of pain.
Let me be grateful again
for the grace of ordinary moments,
where God dwells.

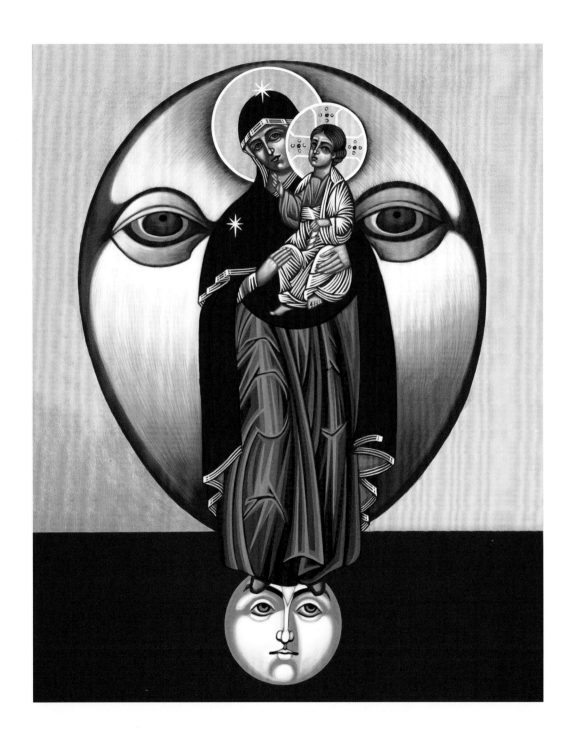

THE WOMAN CLOTHED WITH THE SUN

Encircled by sunlight,

rooted in moonlight,

you hold up the light of the Holy One and offer it

as a remedy for a troubled world, Blessed Mother.

With valor and humility

you reflect the radiance of the Source

and guide our path to safety.

Whenever we attempt to give birth

to something beautiful and true

the dragons of this world seem to crop up

and try to eradicate it.

As we strive to nurture righteousness inside ourselves

destructive forces tend to invade the refuge of our souls

and threaten it.

Wrap me in your protective light, Mother Mary,

so that I may in turn protect the holiness I carry.

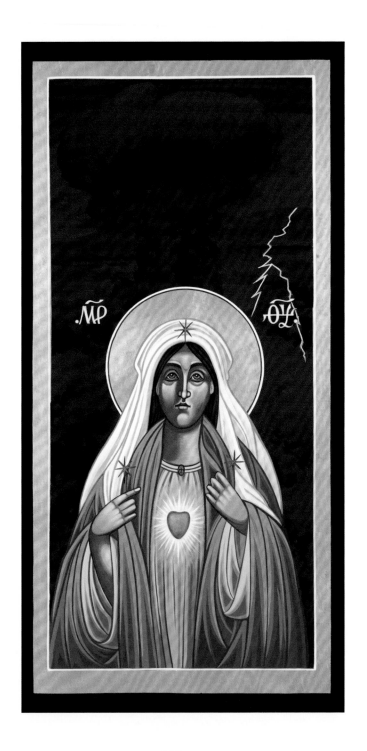

THE TRIUMPH OF THE IMMACULATE HEART

*Y*ou who radiate peace, dear Mary,

help us to break this obsession with war

and vanquish the culture of death.

Too many people have died, Blessed Mother,

and no amount of official explanations

and strategic manipulations

can possibly justify such suffering.

At this very moment, all over the planet,

dozens of battles are raging,

like bursts of flame exploding

from different zones of a forest on fire.

Whether they take the form

of the massive bloodshed of entire communities

or single acts of domestic violence,

your Mother-Heart will not tolerate such hatred.

You break yourself open

and offer us the only true antidote

to the poison of global strife:

universal love.

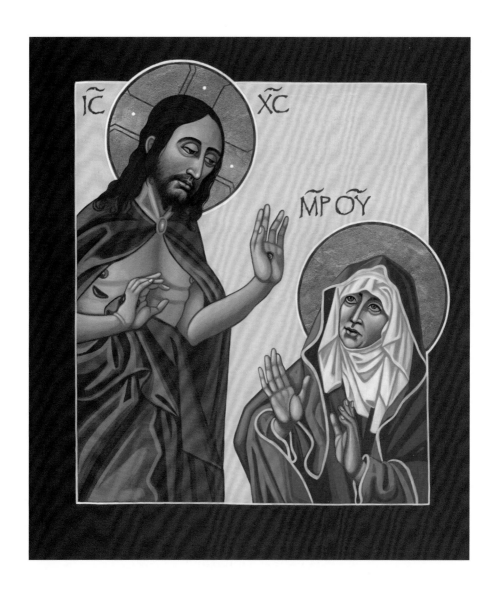

THE RISEN CHRIST APPEARS TO HIS MOTHER

Beloved Mother,
you who bear witness
to life everlasting:
we need you now more than ever.
The House of God is on fire.
Powerful men, once helpless,
Perpetuate the cycle of violence
And violate helpless children.
Religious leaders of all faiths,
plagued with doubt,
wield swords to force conversion
and silence dissent.
As your crucified child
rose up with radiant tenderness
and vulnerable beauty
to bless us forever,
let new life spring
from the death now unfolding:
a new house, built on love,
its doors flung open to all the world.

NOTES ON THE ICONS
William Hart McNichols

1. *Mother of God Similar to Fire*
This was one of the earliest Icons I copied. I was drawn in by the poetic title and never tire of the mystery around it.

2. *Mother of God of Akita, Our Lady of the Snows*
When you begin to paint (write) Icons it seems like all the apparitions of Mary come to you. Akita (in Japan) holds a deep and ever-warm place in my heart. In April of 1999 I was actually there. I will never forget the joy I felt being near the miraculous statue carved by a Buddhist sculptor.

3. *Mary Most Holy Mother of All Nations*
Sometimes in this vocation someone would come with a message or locution from someone in the heavens asking for an Icon. This is how this Icon began. These things have to be discerned – true, or simply a person's desire? The title was given to me and when, in my imagination, I saw the flames of the Holy Spirit around the world I knew I had to paint it. The origins of this Icon are both accepted apparitions in Amsterdam and Akita.

4. *Our Lady of the Apocalypse*
In his book, *First Glance at Adrienne von Speyr,* Hans Urs von Balthasar recalls a vision Adrienne had of Chapter 12 of the Apocalypse (Revelation) in which she saw and heard the Mother cry out in labor. Since she was a doctor, she wanted to do something and she turned to Father Hans, imploring him. He simply said, "Help her."

5. *Nuestra Señora de las Nieves*
One of my best friends' father wanted to give his wife an Icon for Christmas and gave me an old Maryknoll holy card of this Madonna in the Snow. I changed the angel in the card for this Seraph and gave her the Spanish title, Nuestra Señora de las Nieves.

6. *Ave Maris Stella (Star of the Sea)*
This is one of the oldest titles of Mary, and my mind immediately goes to Star of the Sea Church in Gloucester, Massachusetts, where the Mother of God holds a small ship in her hands. We are all rocked by waves at times, and this Icon speaks to the playful agility of the young mother and child riding the waves.

7. *Black Madonna, Your Lap Has Become the Holy Table*
This Icon I painted in honor of the Eucharistic year of 2000. I love the evocation of the Tabernacle as Mary's womb.

8. *Mother of God, Cenacle of the New Pentecost*
Both John XXIII and John Paul II saw the coming age not with fear and suspicion but as the white fire of the Spirit bringing a new Pentecost. I don't have a verbal answer as to why I chose to make Mary and the Child from India.

9. *The Andronicus Icon of the Mother of God, Consoler of Women*
As Holy Prophet Philip Berrigan lay dying in December, 2002, I held him, his wife and Prophet too, Elizabeth, in my heart and prayers. For them I painted this Icon which sat on a chair near his bed until he died on December 6. This Icon resides in Baltimore, Maryland, at Jonah House, where consolers of women work for jsutice.

10. *Mother of God, She Who Hears the Cries of the World*
During the time before September 11, 2001, I felt an agitation I could not put down. At the same time I was deep into reading Chinese, Japanese and Christian accounts of the Merciful Kwan Yin (Konan in Japan). One of her titles I shared with the Mother of God, "She Who Hears the Cries of the World."

11. *Nuestra Señora de los Dolores*
"At the Cross her station keeping / stood the mournful Mother weeping / close to Jesus to the last." Throughout grade school and high school we chanted this haunting hymn all through Lent. Who has not seen this Mother on the news, day and night?

12. *The Dormition of the Mother of God*
The Dormition is a magnificent meditation! Here we see the Son cradling the Mother's soul, when in thousands of images, she holds him.

13. *Mount Sinai Theotokos, the Burning Bush*
One of my best friends' daughter married into a Greek family, and as their wedding present I offered this Icon of the burning bush from Mt. Sinai.

14. *Mother of Fairest Love*
This Icon was a surprise gift to my mother with the names of my father, her name, and my siblings, circling around this most tender Mother of God.

15. *Umelenie, Holy Mother of God, Joy of All Joys*
The great Russian saint, Seraphim of Sarov, was deeply devoted to this Mother of God, "Joy of All Joys." He actually died in prayer before this Icon.

16. *The Holy Protection of the Mother of God*
As the bones of the child abuse plague began to be uncovered in Albuquerque in 1991, we sought help beneath the protecting veil of the Mother of God.

17. *Mother of the Incarnate Word*
This Icon was commissioned by Jesuit theological students. They asked for an Icon about theology. You see here that Mary holds and contemplates the Word as Scripture, while she is also pregnant with the Word.

18. *Our Lady of Kazan*
The Kazanskya Icon has a long and moving traveling history. Her most tender gaze and the upright though childlike stance of Jesus all reward you with soft and intense meetings.

19. *In Kibeho, Mother of the Word*
Currently I believe the messages of Our Lady of Kibeho to be the most urgent of all the recent apparitions. This is why I included both images of her venerating and enfolding the Word.

20. *La Morenita de Montserrat*
St. Ignatius kept an all-night vigil in front of this Black Madonna, praying into, finding, listening for his new way. At dawn he left his sword before the Madonna and, like the wise men in Luke, followed another way home.

21. *La Sagrada Familia*
I wanted to focus more on Joseph in this family Icon. I didn't realize the image was in a heart-shape until after I'd finished.

22. *Our Lady of the Lake*
This challenging commission from my friend Father Rick, Pastor of Our Lady of the Lake in Branson, Missouri, came to me as quite a visual koan. Christ is the morning and evening star above the Mother and we are drawn to both their lights. The finished Icon is still a mystery to me and I hope a living meditation for the church in Branson.

23. *Mother of God, Life-Giving Spring*
Many of my friends suffer from fibromyalgia. While I painted this Icon for one friend in particular, it is for everyone who suffers from chronic pain. I first saw the Icon of Life-Giving Spring in the 1980s at a Greek church in Tampa, Florida, and it was burned into my artistic memory at that time.

24. *Mother of God, Light in All Darkness*
The National Catholic AIDS network commissioned this Icon for people with HIV-AIDS. I envisioned the person praying with this Icon as the candle being sheltered by the Child's tender hand as well as the Mother's protecting adult hand.

25. *Our Lady of Loreto*
Part of my education as a child came from the Sisters of the Precious Blood and part from the Sisters of Loretto. Everything I feel and know of Catholicism began with the wisdom of these women. This Icon was commissioned by Our Lady of Loreto Church in Brooklyn, New York, for their 100th anniversary.

26. *Madonna della Strada*
I wanted to paint all the Icons of the Mother of God associated with the Society of Jesus (the Jesuits), and I was blessed to be able to copy three: Mater Domini, Madonna della Strada, and Our Lady of Montserrat.

27. *Mother of God of Magadan*
Archbishop Hurley of Anchorage, Alaska, commissioned this Icon for the

Orthodox Bishop of Magadan, Russia. Magadan was a concentration camp for the Soviet Union from 1938 to 1955. I could only imagine a Pieta.

28. *Our Lady of Medjugorje, the Burning Bush*
I first read about the apparitions in Bosnia in a book by René Laurentin around 1984. Through the awesome generosity of my friend Mimi, I have been able to visit Medjugorje four times now. The apparitions are not yet approved because they are still happening. Father Svetozar commissioned this Icon along with St. John the Forerunner for the Friary in Medjugorje.

29. *Mother of God, Mystical Rose*
On Christmas Eve in 1993 I was accidentally left alone. At first I felt very sorry for myself—abandoned and all—and then slowly it dawned on me that I could finish this Icon I had begun during Advent. I've never had a more beautiful Christmas Eve. The title comes from the Litany of Loreto.

30. *Mother and Child of Kibeho*
One of my best friends' younger brother wanted to give his wife a Black Madonna for Christmas 2009. I asked if I could do another Kibeho, Mother of God. I had made this drawing around 1987 and felt that this image would be just right.

31. *Our Lady of the New Advent, Burning Bush*
As it became clear that Pope John Paul II would come to Denver in August, 1993, for World Youth Day, Cardinal Stafford commissioned another Icon of Our Lady of the New Advent to be presented to the Holy Father. If the first Icon of the New Advent Mother of God changed my life forever, meeting Pope John Paul continues to do so. One cannot step into his radiant holiness without being transformed.

32. *Our Lady of the New Advent, Gate of Heaven*
The commissioning of this Icon from the Archdiocese of Denver's Cardinal Stafford in 1991 was, unbeknownst to me, an annunciation of not only the New Advent, but an entirely new life for me as well.

33. *Nuestra Señora de las Sandias*
When I first moved to Albuquerque September 7, 1990, I was daily involved with contemplating the Sandias. The eroded surface of these mountains changes with every season. A professor of Spanish at the University of New Mexico taught me that sandia is an archaic Spanish word for "fiery at night." One of my best friends commissioned this image, which became the first of my Icons to be published.

34. *Nursing Icon of the Mother of God*
After my mother died in August, 2006, the family had to face the first Christmas without her. I began to learn, in a very real way, that the Mother is Christmas. That December all I could do was honor her with the Nursing Icon.

35. *Mother of God Overshadowed by the Holy Spirit*
This Icon was commissioned by Weston School of Theology for their chapel in Massachusetts dedicated to the Holy Spirit. After I finished the Icon I read the account of the Overshadowing in Anne Catherine Emmerich's *The Life of the Blessed Virgin Mary* and was profoundly grateful for the similarities.

36. *The Petrovskya Icon of the Mother of God*
R.C. Gorman, the deceased Navajo artist, called the "Indian Picasso," commissioned a Brown Madonna from me and I chose the prototype of the Petrovskya Icon for him.

37. *Our Lady of Pochaev*
As a result of painting (writing) Our Lady of Magadan I was privileged to travel to the Far East in 1995. While there, I visited the new Lavra (monastery) of St. Sergius of Radonezh. The monks there asked me to write for them the glorious Icon of Our Lady of Pochaev. What an experience of shimmering love, light, and strength!

38. *Mary of the Magnificat, Mother of the Poor*
CAFOD of London commissioned this Icon as the visual reflection of their spiritual essence: "tackling poverty and injustice."

39. *Mother of God Rejoicing*
I felt nothing but sheer delight when I first saw this Icon on the cover of *National Geographic* of the twisting, turning child held fast by Our Mother. Also there is that spontaneous instant captured, as with a Polaroid camera shot, when they both look right into you.

40. *The Shrine of Saint Anne*
This Icon was commissioned by the Church of the Shrine of St. Anne in Arvada, Colorado. When I found the Greek prototype, something inside me leapt for joy at the three-tiered Grandmother, Mother, and Child.

41. *Mother of God, Seeker after the Lost*
Sometimes a couple will commission an Icon and give me the freedom to choose. Generally I pick one of the Marian Icons I have not yet encountered. This title, so endearing, brings us all home.

42. *Mother of God, Soothe My Sorrows*
I had seen this exquisite Icon at the Orthodox Monastery in Brookline, Massachusetts. After 9/11 it seemed like the most natural way to invoke the Mother of God.

43. *Mother of God, Stone Broke Loose from the Mountain*
This Icon was commissioned for the school chapel at Regis College in Toronto. I wanted to give them a particularly rich, theologically opening and re-opening image. This Icon is based on Daniel 2:34.

44. *The Three-Handed Icon of the Mother of God*
This Icon, associated with the miraculous healing of the defender of Icons, St. John of Damascus, is arresting and reminds us of the cost of belief.

45. *Mother of God Vatopedi*
This was one of my earliest Icons, from the Vatopedi Monastery on Mount Athos. It has always been popular, I think, because of the Mother kissing the Child's hand.

46. *Virgin of Tenderness of Yaroslavl*
The original, or prototype, of this Icon is infinitely tender and elegant all at once. I was honored to try to give a love-filled rendition.

47. *Mother of God, Virgin of the Don*
The Don is a river in Russia and the prototype is living at the Don Monastery near Moscow. A most tender and loving parishioner at our church in Ranchos de Taos, New Mexico, commissioned this Icon when she was in deep pain, and she tells me the Mother of God enlightens and sustains her. I was somehow unusually charmed by the gold sandals on the Child.

48. *Our Lady of Grace, Vladimir*
This was my second Icon. Our Lady of Vladimir has been called "the soul of Russia."

49. *The Woman Clothed with the Sun*
I saw this prototype at an exhibit of Icons at the American Bible Society in Manhattan, and then I painted this Icon for a friend. I was so charmed by the large sun face and the dancing moon that when I returned I asked the curator if she would send me a photo so I could copy it.

50. *Triumph of the Immaculate Heart*
After reading into and absorbing the accounts of Our Lady of Fatima and the miracle of the Falling Sun I was left to ponder what was being said that day as the ball of fire almost scorched the earth. Was it a warning of a falling star, meteorite, or our own self-destruction? Our Lady of Fatima promised us that in the end her Immaculate Heart would triumph.

51. *The Risen Christ Appears to His Mother*
At the heart of recent Marion apparitions is the prophecy that the Church will undergo death and resurrection to be conformed to the Lamb of God. This past Easter a staggering new pageant of victims of violence came forward as the retinue of the Lamb. I turned to Rogier van der Weyden's masterpiece of a still shaking, vulnerable Risen Christ appearing to his Mother.